POPE BENEDICT XVI
THE FATHERS
VOLUME I

POPE BENEDICT XVI

THE FATHERS

VOLUME I

St. Clement to St. Paulinus of Nola

ILLUSTRATED EDITION

Our Sunday Visitor Publishing Division
Our Sunday Visitor, Inc.
Huntington, Indiana 46750

Copyright © 2009 Libreria Editrice Vaticana

Copyright © 2009 by Our Sunday Visitor Publishing Division
Our Sunday Visitor, Inc. Published 2009

14 13 12 11 10 09 1 2 3 4 5 6 7 8 9

ISBN: 978-1-59276-613-0 (Inventory No. T895)
LCCN: 2009927880

Cover design by Tyler Ottinger
Interior design by Sherri L. Hoffman

Illustration research: Ultreya, Milan (Italy)

Cover art: *The Fathers of the Eastern Church*, mosaic from a sketch by
Edward Burne-Jones, Rome, Basilica of St. Paul Outside-the-Walls;
Photoservice Electa/AKG Images

PRINTED IN CANADA

Contents

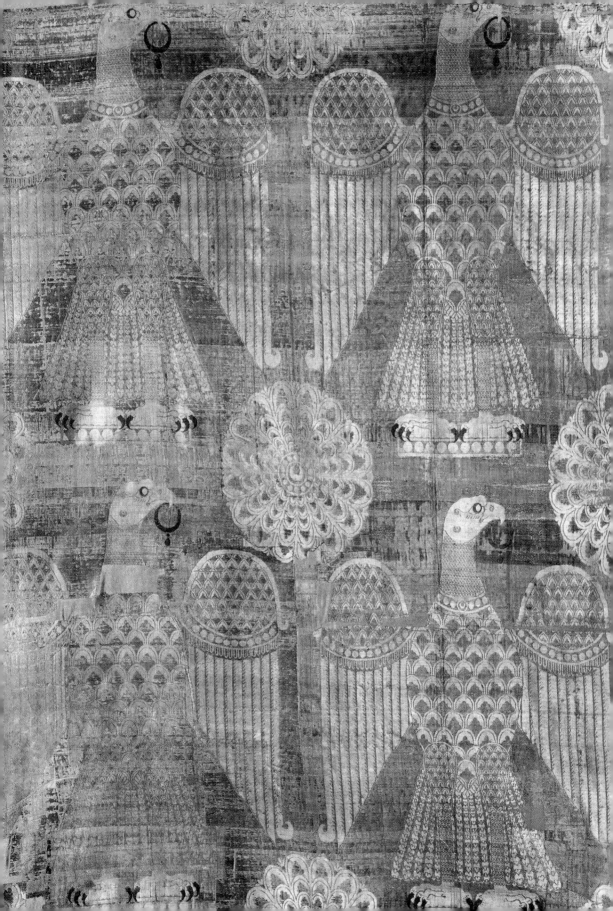

Shroud of St. Eusebius, Auxerre (France), Church of St. Eusebius

On pages 8–9: Panel with scenes from the life of St. Clement, Barcelona (Spain), Museu Nacional d'Art Catalunya

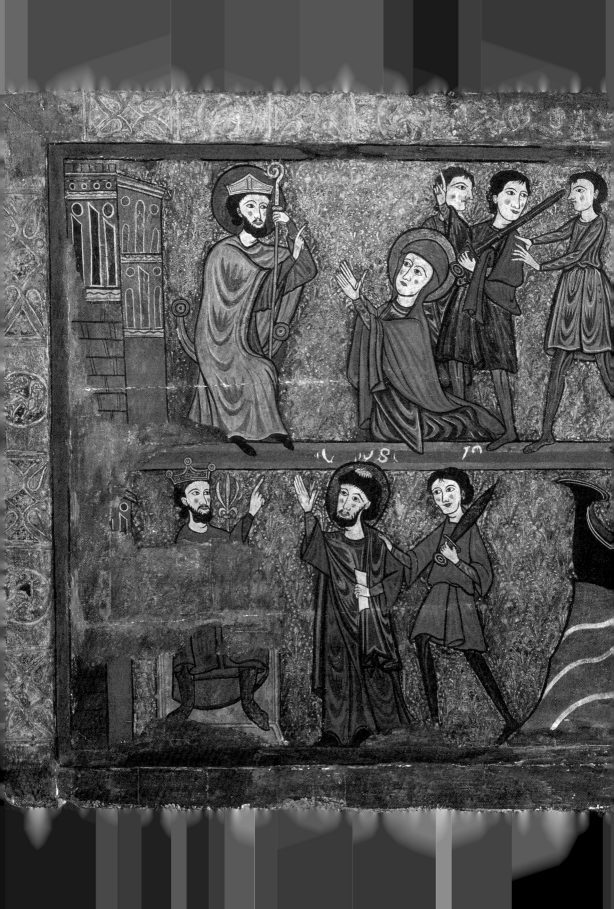

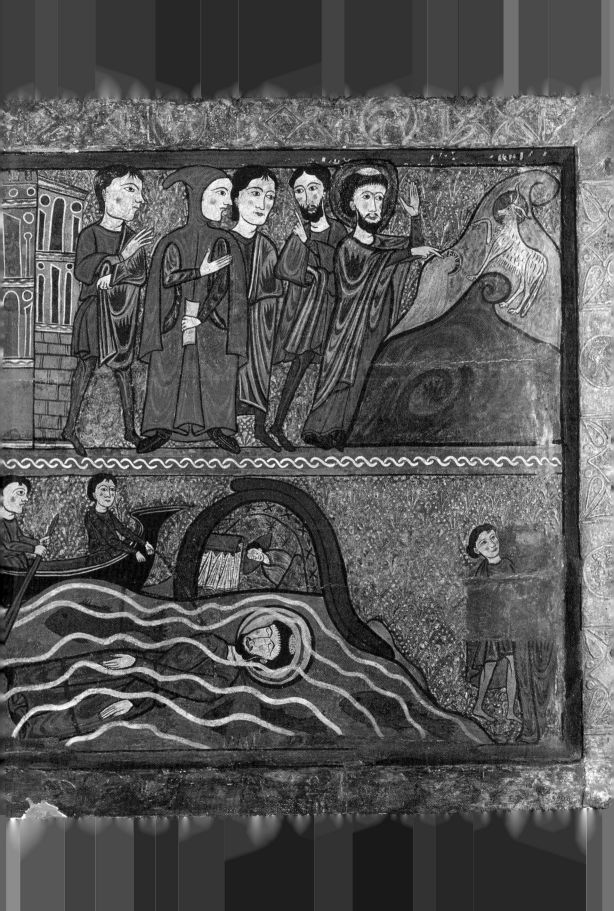

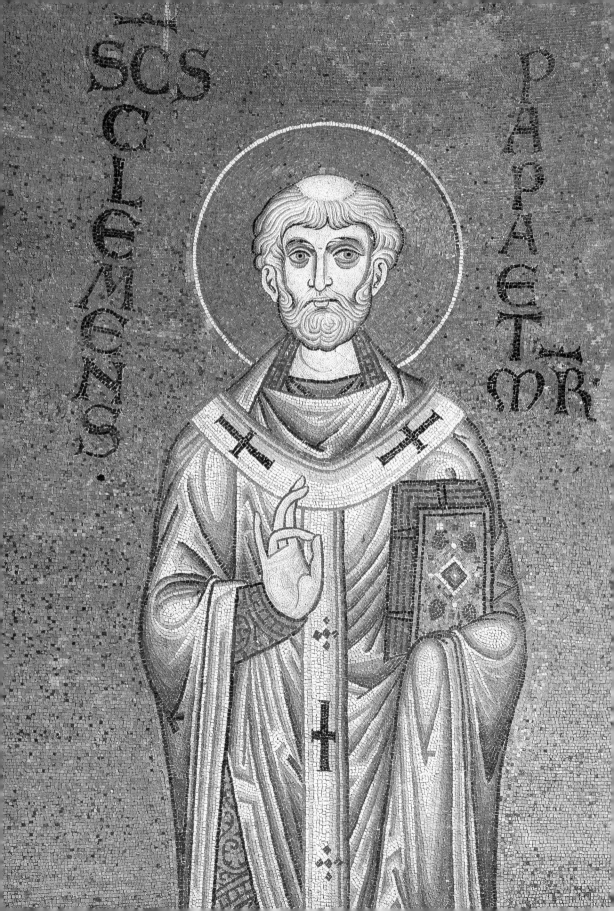

SCS CLEMENS PAPA ET MR

CHAPTER ONE

St. Clement, Bishop of Rome[1]

Let us now devote our attention to the Apostolic Fathers; that is, to the first and second generations in the Church subsequent to the Apostles. And thus, we can see where the Church's journey begins in history.

St. Clement, Bishop of Rome in the last years of the first century, was the third Successor of Peter, after Linus and Anacletus. The most important testimony concerning his life comes from St. Irenaeus, Bishop of Lyons until 202. He attests that Clement "had seen the blessed Apostles," "had been conversant with them," and "might be said to have the preaching of the apostles still echoing [in his ears], and their traditions before his eyes" (*Adversus Haer.* 3, 3, 3).

Later testimonies that date back to between the fourth and sixth centuries attribute to Clement the title of martyr.

The authority and prestige of this Bishop of Rome were such that various writings were attributed to him, but the only one that is certainly his is the *Letter to the Corinthians.* Eusebius of Caesarea, the great "archivist" of Christian beginnings, presents it in these terms: "There is

[1] Editor's note: The material in this book is derived from catechesis given by Pope Benedict XVI during his weekly general audiences from March 7, 2007, to December 12, 2007. The texts have been edited slightly to facilitate presentation in book form. The date each address was originally presented is annotated in the footnotes.

St. Clement, mosaic, Monreale (Italy), the Duomo

extant an epistle of this Clement which is acknowledged to be genuine and is of considerable length and of remarkable merit. He wrote it in the name of the Church of Rome to the Church of Corinth, when a sedition had arisen in the latter Church. We know that this epistle also has been publicly used in a great many Churches both in former times and in our own" (*Hist. Eccl.* 3, 16).

An almost canonical character was attributed to this letter. At the beginning of this text — written in Greek — Clement expressed his regret that "the sudden and successive calamitous events which have happened to ourselves" (*Hist. Eccl.*, 1,1) had prevented him from intervening sooner. These "calamitous events" can be identified with Domitian's persecution; therefore, the letter must have been written just after the Emperor's death and at the end of the persecution — that is, immediately after the year 96.

Clement's intervention — we are still in the first century — was prompted by the serious problems besetting the Church in Corinth: the elders of the community, in fact, had been deposed by some young contestants. The sorrowful event was recalled once again by St. Irenaeus who wrote: "In the time of this Clement, no small dissension having occurred among the brethren in Corinth, the Church in Rome dispatched a most powerful Letter to the Corinthians exhorting them to peace, renewing their faith, and declaring the tradition which it had lately received from the Apostles" (*Adv. Haer.* 3, 3, 3).

Thus, we could say that this letter was a first exercise of the Roman primacy after St. Peter's death. Clement's letter touches on topics that were dear to St. Paul, who had written two important letters to the Corinthians, in particular the theological dialectic, perennially current, between the *indicative* of salvation and the *imperative* of moral commitment.

First of all came the joyful proclamation of saving grace. The Lord forewarns us and gives us his forgiveness, gives us his love and the grace to be Christians, his brothers and sisters.

The Miracle of the Black Sea, Rome, Basilica of St. Clement

The Martyrdom of Pope Clement I, London, British Library, Ms. Royal 20 D. VI, f. 97

It is a proclamation that fills our life with joy and gives certainty to our actions: the Lord always forewarns us with his goodness, and the Lord's goodness is always greater than all our sins.

However, we must commit ourselves in a way that is consistent with the gift received and respond to the proclamation of salvation with a generous and courageous journey of conversion.

In comparison with the Pauline model, the innovation added by Clement is to the doctrinal and practical sections, which constituted all the Pauline letters, a "great prayer" that virtually concludes the letter.

The letter's immediate circumstances provided the Bishop of Rome with ample room for an intervention on the Church's identity and mission. If there were abuses in Corinth, Clement observed, the reason should be sought in the weakening of charity and of the other indispensable Christian virtues.

He therefore calls the faithful to humility and fraternal love, two truly constitutive virtues of being in the Church: "Seeing, therefore, that we are the portion of the Holy One," he warns, "let us do all those things which pertain to holiness" (*Adv. Haer.*, 30, 1).

In particular, the Bishop of Rome recalls that the Lord himself, "where and by whom he desires these things to be done, he himself has fixed by his own supreme will, in order that all things, being piously done according to his good pleasure, may be acceptable unto him. . . . For his own peculiar services are assigned to the high priest, and their own proper place is prescribed to the priests, and their own special ministries devolve on the Levites. The layman is bound by the laws that pertain to laymen" (*Adv. Haer.*, 40, 1–5: it can be noted that here, in this early first-century letter, the Greek word "*laikós*" appears for the first time in Christian literature, meaning "a member of the *laos*," that is, "of the People of God.").

In this way, referring to the liturgy of ancient Israel, Clement revealed his ideal Church. She was assembled by "the one Spirit of grace poured out upon us" which breathes on the various members of the Body of

Christ, where all, united without any divisions, are "members of one another" (*Adv. Haer.*, 46, 6–7).

The clear distinction between the "lay person" and the hierarchy in no way signifies opposition, but only this organic connection of a body, an organism with its different functions. The Church, in fact, is not a place of confusion and anarchy where one can do what one likes all the time: each one in this organism, with an articulated structure, exercises his ministry in accordance with the vocation he has received.

With regard to community leaders, Clement clearly explains the doctrine of Apostolic Succession. The norms that regulate it derive ultimately from God himself. The Father sent Jesus Christ, who in turn sent the Apostles. They then sent the first heads of communities and established that they would be succeeded by other worthy men.

Everything, therefore, was made "in an orderly way, according to the will of God" (*Adv. Haer.*, 42). With these words, these sentences, St. Clement underlined that the Church's structure was sacramental and not political.

The action of God who comes to meet us in the liturgy precedes our decisions and our ideas. The Church is above all a gift of God and not something we ourselves created; consequently, this sacramental structure does not only guarantee the common order but also this precedence of God's gift which we all need.

Finally, the "great prayer" confers a cosmic breath to the previous reasoning. Clement praises and thanks God for his marvelous providence of love that created the world and continues to save and sanctify it.

The prayer for rulers and governors acquires special importance. Subsequent to the New Testament texts, it is the oldest prayer extant for political institutions. Thus, in the period following their persecution, Christians, well aware that the persecutions would continue, never ceased to pray for the very authorities who had unjustly condemned them.

The reason is primarily Christological: it is necessary to pray for one's persecutors as Jesus did on the Cross.

But this prayer also contains a teaching that guides the attitude of Christians toward politics and the state down through the centuries. In praying for the authorities, Clement recognized the legitimacy of political institutions in the order established by God; at the same time, he expressed his concern that the authorities would be docile to God, "devoutly in peace and meekness exercising the power given them by [God]" (*Adv. Haer.*, 61, 2).

Caesar is not everything. Another sovereignty emerges whose origins and essence are not of this world but of "the heavens above": it is that of Truth, which also claims a right to be heard by the state.

Thus, Clement's letter addresses numerous themes of perennial timeliness. It is all the more meaningful since it represents, from the first century, the concern of the Church of Rome that presides in charity over all the other Churches.

In this same Spirit, let us make our own the invocations of the "great prayer" in which the Bishop of Rome makes himself the voice of the entire world: "Yes, O Lord, make your face to shine upon us for good in peace, that we may be shielded by your mighty hand . . . through the High Priest and Guardian of our souls, Jesus Christ, through whom be glory and majesty to you both now and from generation to generation, for evermore."

CHAPTER TWO

St. Ignatius of Antioch[1]

W̶e have spoken of Pope Clement I, the third Successor of St. Peter. Now, we will be speaking of St. Ignatius, who was the third Bishop of Antioch from 70 to 107, the date of his martyrdom. At that time, Rome, Alexandria, and Antioch were the three great metropolises of the Roman Empire. The Council of Nicaea mentioned three "primacies": Rome, but also Alexandria and Antioch participated in a certain sense in a "primacy."

St. Ignatius was Bishop of Antioch, which today is located in Turkey. Here in Antioch, as we know from the Acts of the Apostles, a flourishing Christian community developed. Its first bishop was the Apostle Peter — or so tradition claims — and it was there that the disciples were "*for the first time called Christians.*" (Acts 11:26).

Eusebius of Caesarea, a fourth-century historian, dedicated an entire chapter of his *Church History* to the life and literary works of Ignatius (Eusebius of Caesarea, *Church History*, 3:36).

Eusebius writes: "The Report says that he [Ignatius] was sent from Syria to Rome, and became food for wild beasts on account of his testimony to Christ. And as he made the journey through Asia under the strictest military surveillance" (he called the guards "ten leopards"

[1] Pope Benedict XVI, General Audience, March 14, 2007.

Domenico Beccafumi, *St. Ignatius of Antioch*, Siena (Italy), Chigi Saracini Collection

in his *Letter to the Romans*, 5:1), "he fortified the parishes in the various cities where he stopped by homilies and exhortations, and warned them above all to be especially on their guard against the heresies that were then beginning to prevail, and exhorted them to hold fast to the tradition of the Apostles."

The first place Ignatius stopped on the way to his martyrdom was the city of Smyrna, where St. Polycarp, a disciple of St. John, was bishop. Here, Ignatius wrote four letters, respectively to the Churches of Ephesus, Magnesia, Tralli, and Rome. "Having left Smyrna," Eusebius continues, Ignatius reached Troas and "wrote again": two letters to the Churches of Philadelphia and Smyrna, and one to Bishop Polycarp.

Thus, Eusebius completes the list of his letters, which have come down to us from the Church of the first century as a precious treasure. In reading these texts one feels the freshness of the faith of the generation that had still known the Apostles. In these letters, the ardent love of a saint can also be felt.

Lastly, the martyr traveled from Troas to Rome, where he was thrown to fierce wild animals in the Flavian Amphitheater.

No Church Father has expressed the longing for *union* with Christ and for *life* in him with the intensity of Ignatius. We therefore read the Gospel passage on the vine, which according to John's Gospel is Jesus. In fact, two spiritual "currents" converge in Ignatius, that of Paul, straining with all his might for *union* with Christ, and that of John, concentrating on *life* in him. In turn, these two currents translate into the *imitation* of Christ, whom Ignatius several times proclaimed as "my" or "our God."

Thus, Ignatius implores the Christians of Rome not to prevent his martyrdom since he is impatient "to attain to Jesus Christ." And he explains, "It is better for me to die on behalf of Jesus Christ than to reign over all the ends of the earth. . . . Him I seek, who died for us: him

Lorenzo Lotto, *Holy Conversation*, detail with St. Ignatius, Rome, Borghese Gallery

On pages 22–23: Franceso Fracanzano, *Martyrdom of St. Ignatius*, Rome, Borghese Gallery

I desire, who rose again for our sake.... Permit me to be an imitator of the Passion of my God!" (St. Ignatius to the *Romans*, 5–6).

One can perceive in these words on fire with love the pronounced Christological "realism" typical of the Church of Antioch, more focused than ever on the Incarnation of the Son of God and on his true and concrete humanity: "Jesus Christ," St. Ignatius wrote to the Smyrnaeans, "was *truly* of the seed of David," "he was *truly* born of a virgin," "and was *truly* nailed [to the Cross] for us" (St. Ignatius to the *Smyrnaeans*, 1:1).

Ignatius's irresistible longing for union with Christ was the foundation of a real "mysticism of unity." He describes himself: "I therefore did what befitted me as a man devoted to unity" (*Philadelphians*, 8:1).

For Ignatius, unity was first and foremost a prerogative of God, who, since he exists as Three Persons, is One in absolute unity. Ignatius often used to repeat that God is unity and that in God alone is unity found in its pure and original state. Unity to be brought about on this earth by Christians is no more than an imitation as close as possible to the divine archetype.

Thus, Ignatius reached the point of being able to work out a vision of the Church strongly reminiscent of certain expressions in Clement of Rome's Letter to the Corinthians.

For example, he wrote to the Christians of Ephesus: "It is fitting that you should concur with the will of your bishop, which you also do. For your justly renowned presbytery, worthy of God, is fitted as exactly to the bishop as the strings are to the harp. Therefore, in your concord and harmonious love, Jesus Christ is sung. And man by man, you become a choir, that being harmonious in love and taking up the song of God in unison you may with one voice sing to the Father..." (4:1–2).

And after recommending to the Smyrnaeans, "Let no man do anything connected with Church without the bishop," he confides to Polycarp: "My soul be for theirs who are submissive to the bishop, to the presbyters and to the deacons, and may my portion be along with them in God! Labor together with one another; strive in company together;

run together; suffer together; sleep together; and awake together as the stewards and associates and servants of God. Please him under whom you fight, and from whom you receive your wages. Let none of you be found a deserter. Let your baptism endure as your arms; your faith as your helmet; your love as your spear; your patience as a complete panoply" (*Polycarp*, 6:1–2).

Overall, it is possible to grasp in the *Letters* of Ignatius a sort of constant and fruitful dialectic between two characteristic aspects of Christian life: on the one hand, the hierarchical structure of the ecclesial community; and on the other, the fundamental unity that binds all the faithful in Christ.

Consequently, their roles cannot be opposed to one another. On the contrary, the insistence on communion among believers and of believers with their pastors was constantly reformulated in eloquent images and analogies: the harp, strings, intonation, the concert, the symphony. The special responsibility of bishops, priests, and deacons in building the community is clear.

This applies first of all to their invitation to love and unity. "Be one," Ignatius wrote to the Magnesians, echoing the prayer of Jesus at the Last Supper: "one supplication, one mind, one hope in love.... Therefore, all run together as into one temple of God, as to one altar, as to one Jesus Christ who came forth from one Father, and is with and has gone to one" (7:1–2).

Ignatius was the first person in Christian literature to attribute to the Church the adjective "catholic" or "universal": "Wherever Jesus Christ is," he said, "there is the Catholic Church" (*Smyrnaeans,* 8:2). And precisely in the service of unity to the Catholic Church, the Christian community of Rome exercised a sort of primacy of love: "The Church which presides in the place of the region of the Romans, and which is worthy of God, worthy of honor, worthy of the highest happiness... and which presides over love, is named from Christ, and from the Father..." (*Romans,* Prologue).

As can be seen, Ignatius is truly the "Doctor of Unity": unity of God and unity of Christ (despite the various heresies gaining ground which separated the human and the divine in Christ), unity of the Church, unity of the faithful in "faith and love, to which nothing is to be preferred" (*Smyrnaeans,* 6:1).

Ultimately, Ignatius's realism invites the faithful of yesterday and today, invites us all, to make a gradual synthesis between *configuration to Christ* (union with him, life in him) and *dedication to his Church* (unity with the Bishop, generous service to the community and to the world).

To summarize, it is necessary to achieve a synthesis between *communion* of the Church within herself and *mission*, the proclamation of the Gospel to others, until the other speaks through one dimension and believers increasingly "have obtained the inseparable Spirit, who is Jesus Christ" (*Magnesians,* 15).

Imploring from the Lord this "grace of unity" and in the conviction that the whole Church presides in charity (cf. *Romans,* Prologue), I address to you yourselves the same hope with which Ignatius ended his *Letter to the Trallians*: "Love one another with an undivided heart. Let my spirit be sanctified by yours, not only now, but also when I shall attain to God.... In [Jesus Christ] may you be found unblemished" (13).

And let us pray that the Lord will help us to attain this unity and to be found at last unstained, because it is love that purifies souls.

Sandro Botticelli, *St. Barnabas Altarpiece*, detail with Sts. John the Baptist, Ignatius, and Michael, Florence (Italy), Uffizi museum

St. Justin, Philosopher and Martyr[1]

In these catecheses, we are reflecting on the great figures of the early Church. Now, we will talk about St. Justin, philosopher and martyr, the most important of the second-century apologist Fathers.

The word "apologist" designates those ancient Christian writers who set out to defend the new religion from the weighty accusations of both pagans and Jews and to spread the Christian doctrine in terms suited to the culture of their time.

Thus, the apologists had a twofold concern: that most properly called "apologetic" to defend the newborn Christianity (*apologhía* in Greek means, precisely, "defense"), and the pro-positive, "missionary" concern, to explain the content of the faith in a language and on a wavelength comprehensible to their contemporaries.

Justin was born in about the year A.D. 100 near ancient Shechem, Samaria, in the Holy Land; he spent a long time seeking the truth, moving through the various schools of the Greek philosophical tradition.

Finally, as he himself recounts in the first chapters of his *Dialogue with Tryphon*, a mysterious figure, an old man he met on the seashore, initially leads him into a crisis by showing him that it is impossible for

[1] Pope Benedict XVI, General Audience, March 21, 2007.

St. Justin, engraving, from André Thévet, *History of the Many Illustrious and Scholarly Men of Their Centuries*, Paris 1671

the human being to satisfy his aspiration to the divine solely with his own forces. He then pointed out to him the ancient prophets as the people to turn to in order to find the way to God and "true philosophy."

In taking his leave, the old man urged him to pray that the gates of light would be opened to him.

The story foretells the crucial episode in Justin's life: at the end of a long philosophical journey, a quest for the truth, he arrived at the Christian faith. He founded a school in Rome where, free of charge, he initiated students into the new religion, considered as the true philosophy. Indeed, in it he had found the truth; hence, the art of living virtuously.

For this reason he was reported and beheaded in about 165 during the reign of Marcus Aurelius, the philosopher-emperor to whom Justin had actually addressed one of his *Apologia*.

These — the two *Apologies* and the *Dialogue with the Hebrew, Tryphon* — are his only surviving works. In them, Justin intends above all to illustrate the divine project of creation and salvation, which is fulfilled in Jesus Christ, the *Logos*; that is, the eternal Word, eternal Reason, creative Reason.

Every person as a rational being shares in the *Logos,* carrying within himself a "seed," and can perceive glimmers of the truth. Thus, the same *Logos* who revealed himself as a prophetic figure to the Hebrews of the ancient Law also manifested himself partially, in "seeds of truth," in Greek philosophy.

Now, Justin concludes, since Christianity is the historical and personal manifestation of the *Logos* in his totality, it follows that "whatever things were rightly said among all men are the property of us Christians" (*Second Apology of St. Justin Martyr,* 13:4).

In this way, although Justin disputed Greek philosophy and its contradictions, he decisively oriented any philosophical truth to the *Logos,*

Maestro della Natività di Castello, *The Madonna with Child and Sts. Clement and Justin*, detail, Prato (Italy), Museo dell'Opera del Duomo

giving reasons for the unusual "claim" to truth and universality of the Christian religion. If the Old Testament leaned toward Christ, just as the symbol is a guide to the reality represented, then Greek philosophy also aspired to Christ and the Gospel, just as the part strives to be united with the whole.

And he said that these two realities, the Old Testament and Greek philosophy, are like two paths that lead to Christ, to the *Logos*. This is why Greek philosophy cannot be opposed to Gospel truth, and Christians can draw from it confidently as from a good of their own.

Therefore, my venerable predecessor, Pope John Paul II, described St. Justin as a "pioneer of positive engagement with philosophical thinking — albeit with cautious discernment.... Although he continued to hold Greek philosophy in high esteem after his conversion, Justin claimed with power and clarity that he had found in Christianity 'the only sure and profitable philosophy' (*Dial.* 8: 1)" (Pope John Paul II, *Fides et Ratio*, n. 38).

Overall, the figure and work of Justin mark the ancient Church's forceful option for philosophy, for reason, rather than for the religion of the pagans. With the pagan religion, in fact, the early Christians strenuously rejected every compromise. They held it to be idolatry, at the cost of being accused for this reason of "impiety" and "atheism."

Justin in particular, especially in his first *Apology*, mercilessly criticized the pagan religion and its myths, which he considered to be diabolically misleading on the path of truth.

Philosophy, on the other hand, represented the privileged area of the encounter between paganism, Judaism, and Christianity, precisely at the level of the criticism of pagan religion and its false myths. "Our philosophy...": this is how another apologist, Bishop Melito of Sardis, a contemporary of Justin, came to define the new religion in a more explicit way (*Ap. Hist. Eccl.* 4, 26, 7).

In fact, the pagan religion did not follow the ways of the *Logos*, but clung to myth, even if Greek philosophy recognized that mythology was devoid of consistency with the truth.

Therefore, the decline of the pagan religion was inevitable: it was a logical consequence of the detachment of religion — reduced to an artificial collection of ceremonies, conventions, and customs — from the truth of being.

Justin, and with him other apologists, adopted the clear stance taken by the Christian faith for the God of the philosophers against the false gods of the pagan religion.

It was the choice of the *truth* of being against the myth of *custom*. Several decades after Justin, Tertullian defined the same option of Christians with a lapidary sentence that still applies: "*Dominus noster Christus veritatem se, non consuetudinem, cognominavit* — Christ has said that he is truth, not fashion" (*De Virgin. Vel.* 1, 1).

It should be noted in this regard that the term *consuetudo*, used here by Tertullian in reference to the pagan religion, can be translated into modern languages with the expressions: "cultural fashion" and "current fads."

In a time like ours, marked by relativism in the discussion on values and on religion — as well as in interreligious dialogue — this is a lesson that should not be forgotten.

To this end, I suggest to you once again — and thus I conclude — the last words of the mysterious old man whom Justin the Philosopher met on the seashore: "Pray that, above all things, the gates of light may be opened to you; for these things cannot be perceived or understood by all, but only by the man to whom God and his Christ have imparted wisdom" (*Dial.* 7:3).

St. Irenaeus of Lyons[1]

In the catechesis on the prominent figures of the early Church, we now come to the eminent personality of St. Irenaeus of Lyons. The biographical information on him comes from his own testimony, handed down to us by Eusebius in his fifth book on Church History.

Irenaeus was in all probability born in Smyrna (today, Izmir, in Turkey) in about 135–140, where in his youth, he attended the school of Bishop Polycarp, a disciple in his turn of the Apostle John. We do not know when he moved from Asia Minor to Gaul, but his move must have coincided with the first development of the Christian community in Lyons: here, in 177, we find Irenaeus listed in the college of presbyters. In that very year, he was sent to Rome bearing a letter from the community in Lyons to Pope Eleutherius. His mission to Rome saved Irenaeus from the persecution of Marcus Aurelius that took a toll of at least 48 martyrs, including the 90-year-old Bishop Pontinus of Lyons, who died from ill treatment in prison. Thus, on his return, Irenaeus was appointed bishop of the city. The new pastor devoted himself without reserve to his episcopal ministry that ended in about 202–203, perhaps with his martyrdom.

[1] Pope Benedict XVI, General Audience, March 28, 2007.

Auguste-Paul-Gustave Cornu, *St. Irenaeus*, Paris, Chapel of the Elysée Palace

Irenaeus was first and foremost a man of faith and a pastor. Like a good pastor, he had a good sense of proportion, of the riches of doctrine and missionary enthusiasm. As a writer, he pursued a twofold aim: to defend true doctrine from the attacks of heretics, and to explain the truth of the faith clearly. His two extant works — the five books of *The Detection and Overthrow of the False Gnosis* and *Demonstration of the Apostolic Teaching* (which can also be called the oldest "catechism of Christian doctrine") — exactly corresponded with these aims. In short, Irenaeus can be defined as the champion in the fight against heresies. The second-century Church was threatened by the so-called *Gnosis,* a doctrine which affirmed that the faith taught in the Church was merely a symbolism for the simple who were unable to grasp difficult concepts; instead, the initiates, the intellectuals — *Gnostics,* they were called — claimed to understand what was behind these symbols and thus formed an elitist and intellectualist Christianity.

Obviously, this intellectual Christianity became increasingly fragmented, splitting into different currents with ideas that were often bizarre and extravagant, yet attractive to many. One element these different currents had in common was "dualism": they denied faith in the one God and Father of all, Creator and Savior of man and of the world. To explain evil in the world, they affirmed the existence, besides the Good God, of a negative principle. This negative principle was supposed to have produced material things, matter.

Firmly rooted in the biblical doctrine of creation, Irenaeus refuted the Gnostic dualism and pessimism which debased corporeal realities. He decisively claimed the original holiness of matter, of the body, of the flesh no less than of the spirit. But his work went far beyond the confutation of heresy: in fact, one can say that he emerges as the first great Church theologian who created systematic theology; he himself speaks of the system of theology — that is, of the internal coherence

Baptism of St. Irenaeus, tapestry detail of Saint-Piat, Tournai (France), the cathedral

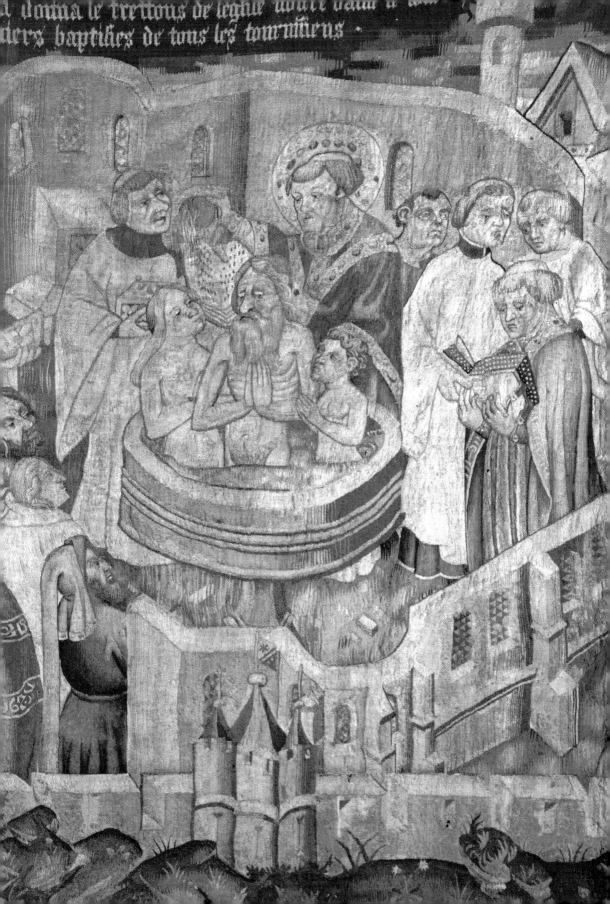

of all faith. At the heart of his doctrine is the question of the "rule of faith" and its transmission. For Irenaeus, the "rule of faith" coincided in practice with the *Apostles' Creed,* which gives us the key for interpreting the Gospel, for interpreting the Creed in light of the Gospel. The Creed, which is a sort of Gospel synthesis, helps us understand what it means and how we should read the Gospel itself.

In fact, the Gospel preached by Irenaeus is the one he was taught by Polycarp, Bishop of Smyrna, and Polycarp's Gospel dates back to the Apostle John, whose disciple Polycarp was.

The true teaching, therefore, is not that invented by intellectuals, which goes beyond the Church's simple faith. The true Gospel is the one imparted by the bishops who received it in an uninterrupted line from the Apostles. They taught nothing except this simple faith, which is also the true depth of God's revelation. Thus, Irenaeus tells us, there is no secret doctrine concealed in the Church's common Creed. There is no superior Christianity for intellectuals. The faith publicly confessed by the Church is the common faith of all. This faith alone is apostolic, it is handed down from the Apostles; that is, from Jesus and from God. In adhering to this faith, publicly transmitted by the Apostles to their successors, Christians must observe what their bishops say and must give special consideration to the teaching of the Church of Rome, pre-eminent and very ancient. It is because of her antiquity that this Church has the greatest apostolicity; in fact, she originated in Peter and Paul, pillars of the Apostolic College. All Churches must agree with the Church of Rome, recognizing in her the measure of the true Apostolic Tradition, the Church's one common faith.

With these arguments, summed up very briefly here, Irenaeus refuted the claims of these Gnostics, these intellectuals, from the start. First of all, they possessed no truth superior to that of the ordinary faith, because what they said was not of apostolic origin. It was invented by them. Secondly, truth and salvation are not the privilege or monopoly of the few, but are available to all through the preaching of the Succes-

sors of the Apostles, especially of the Bishop of Rome. In particular —
once again disputing the "secret" character of the Gnostic tradition and
noting its multiple and contradictory results — Irenaeus was concerned
with describing the genuine concept of the Apostolic Tradition which
we can sum up here in three points.

a) Apostolic Tradition is "public," not private or secret. Irenaeus did
not doubt that the content of the faith transmitted by the Church is
that received from the Apostles and from Jesus, the Son of God. There
is no other teaching than this. Therefore, for anyone who wishes to
know true doctrine, it suffices to know "the Tradition passed down by
the Apostles and the faith proclaimed to men": a tradition and faith that
"have come down to us through the succession of Bishops" (*Adversus
Haereses,* 3, 3, 3–4). Hence, the succession of bishops, the personal
principle, and Apostolic Tradition, the doctrinal principle, coincide.

b) Apostolic Tradition is "one." Indeed, whereas Gnosticism was
divided into multiple sects, Church Tradition is one in its fundamental
content, which — as we have seen — Irenaeus calls precisely *regula
fidei* or *veritatis:* and thus, because it is one, it creates unity through the
peoples, through the different cultures, through the different peoples;
it is a common content like the truth, despite the diversity of languages
and cultures. A very precious saying of St. Irenaeus is found in his
book *Adversus Haereses:* "The Church, though dispersed throughout the
world... having received [this faith from the Apostles]... as if occupying
but one house, carefully preserves it. She also believes these points [of
doctrine] just as if she had but one soul and one and the same heart,
and she proclaims them, and teaches them and hands them down with
perfect harmony as if she possessed only one mouth. For, although the
languages of the world are dissimilar, yet the import of the tradition
is one and the same. For the Churches which have been planted in

On pages 40–41: *St. Irenaeus Revives the Tribunal's Daughter and Baptizes Her,*
tapestry detail of Saint-Piat, Tournai (France), the cathedral

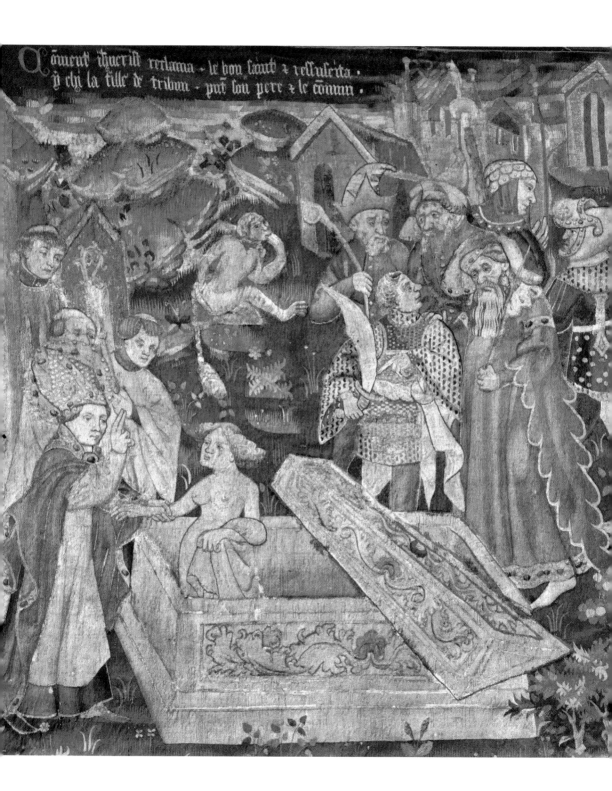

40

41

Germany do not believe or hand down anything different, nor do those in Spain, nor those in Gaul, nor those in the East, nor those in Egypt, nor those in Libya, nor those which have been established in the central regions of the world" (1, 10, 1–2). Already at that time — we are in the year 200 — it was possible to perceive the Church's universality, her catholicity and the unifying power of the truth that unites these very different realities, from Germany, to Spain, to Italy, to Egypt, to Libya, in the common truth revealed to us by Christ.

c) Lastly, the Apostolic Tradition, as he says in the Greek language in which he wrote his book, is "pneumatic," in other words, spiritual, guided by the Holy Spirit: in Greek, the word for "spirit" is *pneuma.* Indeed, it is not a question of a transmission entrusted to the ability of more or less learned people, but to God's Spirit who guarantees fidelity to the transmission of the faith.

This is the "life" of the Church, what makes the Church ever young and fresh, fruitful with multiple charisms.

For Irenaeus, Church and Spirit were inseparable: "This faith," we read again in the third book of *Adversus Haereses,* "which, having been received from the Church, we do preserve, and which always, by the Spirit of God, renewing its youth as if it were some precious deposit in an excellent vessel, causes the vessel itself containing it to renew its youth also.... For where the Church is, there is the Spirit of God; and where the Spirit of God is, there is the Church and every kind of grace" (3, 24, 1). As can be seen, Irenaeus did not stop at defining the concept of Tradition. His tradition, uninterrupted Tradition, is not traditionalism, because this Tradition is always enlivened from within by the Holy Spirit, who makes it live anew, causes it to be interpreted and understood in the vitality of the Church.

Adhering to her teaching, the Church should transmit the faith in such a way that it must be what it appears; that is, "public," "one," "pneumatic," "spiritual." Starting with each one of these characteristics, a fruitful discernment can be made of the authentic transmission of the

faith in the *today* of the Church. More generally, in Irenaeus's teaching, the dignity of man, body and soul, is firmly anchored in divine creation, in the image of Christ and in the Spirit's permanent work of sanctification. This doctrine is like a "high road" in order to discern together with all people of good will the object and boundaries of the dialogue of values, and to give an ever-new impetus to the Church's missionary action, to the force of the truth which is the source of all true values in the world.

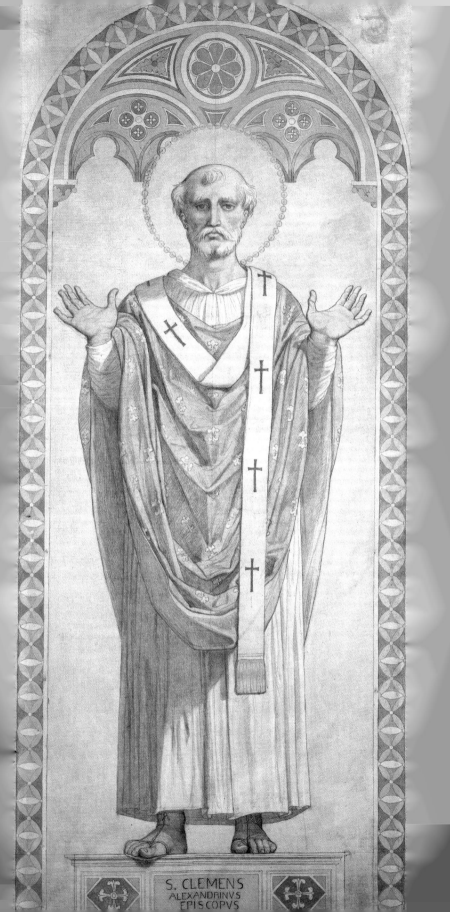

S. CLEMENS
ALEXANDRINVS
EPISCOPVS

St. Clement of Alexandria[1]

In the last chapter, we spoke of St. Irenaeus of Lyons. Let us now speak of Clement of Alexandria, a great theologian who was probably born in Athens at around the middle of the second century.

From Athens he inherited that marked interest in philosophy that was to make him one of the pioneers of the dialogue between faith and reason in the Christian tradition. While he was still young, he arrived in Alexandria, the "city-symbol" of that fertile junction between the different cultures that was a feature of the Hellenistic age.

He was a disciple of Pantaenus until he succeeded him as head of the catechetical school. Many sources testify that he was ordained a priest. During the persecution of 202–203, he fled from Alexandria, seeking refuge in Caesarea, Cappadocia, where he died in about 215.

Of his most important works, three are extant: the *Protrepticus*, the *Paedagogus*, and the *Stromata*. Although it does not seem that this was the author's original intention, it is a fact that these writings constitute a true trilogy, destined to effectively accompany the Christian's spiritual growth.

[1] Pope Benedict XVI, General Audience, April 18, 2007.

Jean-Auguste-Dominique Ingres, *St. Clement*, sketch for the window of the Chapel of St. Ferdinand, Paris, Louvre museum

The *Protrepticus,* as the word itself suggests, is an "exhortation" addressed to those who are starting out and seeking the path of faith. Better still, the *Protrepticus* coincides with a Person: the Son of God, Jesus Christ, who makes himself the exhorter of men and women so that they will set out towards the Truth with determination.

Jesus Christ himself becomes the *Paedagogus*; that is, the "tutor" of those who, by virtue of baptism, have henceforth become children of God.

Lastly, Jesus Christ himself is also the *Didascalos,* the "Master" who presents the most profound teachings. These are gathered in Clement's third work, the *Stromata,* a Greek term which means "tapestries"; indeed, they are a random composition of different topics, direct fruits of Clement's customary teaching.

Overall, Clement's catecheses accompanied the catechumens and the baptized step by step on their way, so that with the two "wings" of faith and reason they might reach intimate knowledge of the Truth which is Jesus Christ, the Word of God. Only this knowledge of the Person who is truth is the "true" *gnosis,* a Greek term which means "knowledge," "understanding." It is the edifice built by reason under the impetus of a supernatural principle.

Faith itself builds true philosophy; that is, true conversion on the journey to take through life. Hence, authentic "gnosis" is a development of faith inspired by Jesus Christ in the soul united with him. Clement then distinguishes two steps in Christian life.

The first step: believing Christians who live the faith in an ordinary way, yet are always open to the horizons of holiness. Then the second step: "Gnostics" — that is, those who lead a life of spiritual perfection.

In any case, Christians must start from the common basis of faith through a process of seeking; they must allow themselves to be guided by Christ and thus attain knowledge of the Truth and of truth that forms the content of faith.

This knowledge, Clement says, becomes a living reality in the soul: it is not only a theory, it is a life force, a transforming union of love. Knowledge of Christ is not only thought, but is love which opens the eyes, transforms the person, and creates communion with the *Logos,* with the Divine Word who is truth and life. In this communion, which is perfect knowledge and love, the perfect Christian attains contemplation, unification with God.

Finally, Clement espouses the doctrine which claims that man's ultimate end is to liken himself to God. We were created in the image and likeness of God, but this is also a challenge, a journey: indeed, life's purpose, its ultimate destination, is truly to become similar to God. This is possible through the co-naturality with him which man received at the moment of creation, which is why, already in himself, he is an image of God. This co-naturality makes it possible to know the divine realities to which man adheres, first of all out of faith; and through a lived faith the practice of virtue can grow until one contemplates God.

On the path to perfection, Clement thus attaches as much importance to the moral requisite as he gives to the intellectual. The two go hand in hand, for it is impossible to know without living and impossible to live without knowing.

Becoming likened to God and contemplating him cannot be attained with purely rational knowledge: to this end, a life in accordance with the *Logos* is necessary, a life in accordance with truth. Consequently, good works must accompany intellectual knowledge just as the shadow follows the body.

Two virtues above all embellish the soul of the "true Gnostic." The first is freedom from the passions *(apátheia)*; the other is love, the true passion that assures intimate union with God. Love gives perfect peace and enables "the true Gnostic" to face the greatest sacrifices, even the supreme sacrifice in following Christ, and makes him climb from step to step to the peak of virtue.

Thus, the ethical ideal of ancient philosophy, that is, liberation from the passions, is defined by Clement and conjugated with love, in the ceaseless process of making oneself similar to God. In this way the Alexandrian creates the second important occasion for dialogue between the Christian proclamation and Greek philosophy.

We know that St. Paul, at the Aeropagus in Athens where Clement was born, had made the first attempt at dialogue with Greek philosophy — and by and large had failed — but they said to him: "We will hear you again."

Clement now takes up this dialogue and ennobles it to the maximum in the Greek philosophical tradition.

As my venerable predecessor John Paul II wrote in his Encyclical *Fides et Ratio*, Clement of Alexandria understood philosophy "as instruction which prepared for Christian faith" (*Fides et Ratio*, n. 38). And in fact, Clement reached the point of maintaining that God gave philosophy to the Greeks "as their own Testament" (*Strom.* 6, 8, 67, 1).

For him, the Greek philosophical tradition, almost like the Law for the Jews, was a sphere of "revelation"; they were two streams which flowed ultimately to the *Logos* himself.

Thus, Clement continued to mark out with determination the path of those who desire "to account" for their own faith in Jesus Christ. He can serve as an example to Christians, catechists and theologians of our time, whom, in the same encyclical, John Paul II urged "to recover and express to the full the metaphysical dimension of faith in order to enter into a demanding critical dialogue with both contemporary philosophical thought and with the philosophical tradition in all its aspects."

Let us conclude by making our own a few words from the famous "prayer to Christ the *Logos*" with which Clement concludes his *Paedagogus*. He implores: *"Be gracious... to us your children.... Grant us that we may live in your peace, be transferred to your city, sail over the billows*

of sin without capsizing, be gently wafted by your Holy Spirit, by ineffable Wisdom, by night and day to the perfect day... giving thanks and praise to the one Father... to the Son, Instructor, and Teacher, with the Holy Spirit. Amen!" (*Paed.* 3, 12, 101).

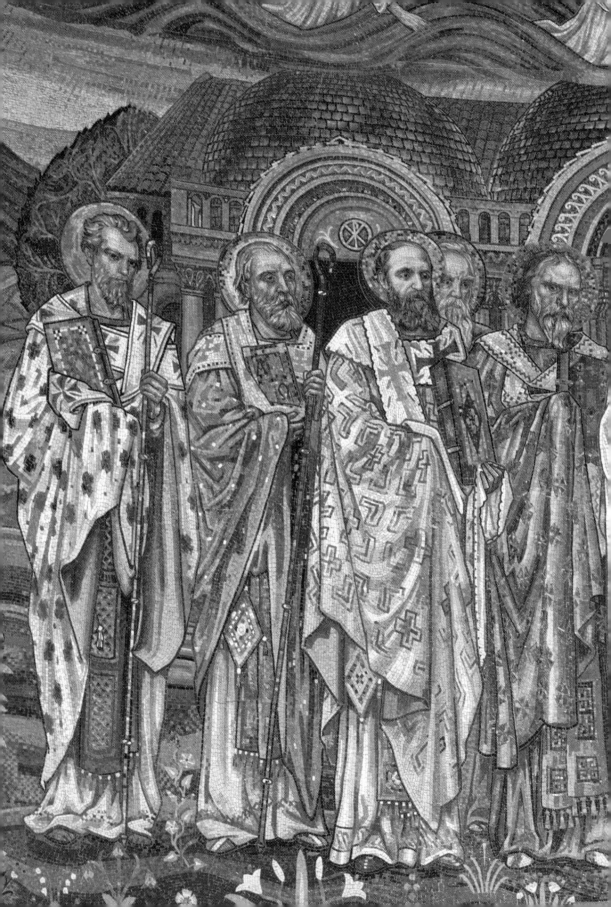

Origen of Alexandria

Life and Writings[1]

In our meditations on the great figures of the early Church, we become acquainted with one of the most remarkable. Origen of Alexandria truly was a figure crucial to the whole development of Christian thought. He gathered up the legacy of Clement of Alexandria, on whom we meditated in the last chapter, and launched it for the future in a way so innovative that he impressed an irreversible turning point on the development of Christian thought.

He was a true "maestro," and so it was that his pupils remembered him with nostalgia and emotion: he was not only a brilliant theologian but also an exemplary witness of the doctrine he passed on. Eusebius of Caesarea, his enthusiastic biographer, said, "His manner of life was as his doctrine, and his doctrine as his life. Therefore, by the divine power working with him, he aroused a great many to his own zeal" (cf. *Church History*, 6, 3, 7).

His whole life was pervaded by a ceaseless longing for martyrdom. He was seventeen years old when, in the tenth year of the reign of Emperor Septimius Severus, the persecution against Christians was unleashed

[1] Pope Benedict XVI, General Audience, April 25, 2007.

The Fathers of the Eastern Church, mosaic from a sketch by Edward Burne-Jones, Rome, Basilica of St. Paul Outside-the-Walls

in Alexandria. Clement, his teacher, fled the city, and Origen's father, Leonides, was thrown into prison. His son longed ardently for martyrdom but was unable to realize his desire. So he wrote to his father, urging him not to shrink from the supreme witness of faith. And when Leonides was beheaded, the young Origen felt bound to welcome the example of his father's life.

Forty years later, while preaching in Caesarea, he confessed: "It is of no use to me to have a martyr father if I do not behave well and honor the nobility of my ancestors — that is, the martyrdom of my father and the witness that made him illustrious in Christ" (*Hom. Ez* 4, 8). In a later homily, when, thanks to the extreme tolerance of the Emperor, Philip the Arab, the possibility of a bloody witness seemed henceforth blurred, Origen exclaims: "If God were to grant me to be washed in my blood so as to receive the second baptism after accepting death for Christ, I would depart this world with assurance.... But those who deserve such things are blessed." These words reveal the full force of Origen's longing for baptism with blood.

And finally, this irresistible yearning was granted to him, at least in part. In the year 250, during Decius's persecution, Origen was arrested and cruelly tortured. Weakened by the suffering to which he had been subjected, he died a few years later. He was not yet 70.

We have mentioned the "irreversible turning point" that Origen impressed upon the history of theology and Christian thought. But of what did this turning point, this innovation so pregnant with consequences, consist? It corresponds in substance to theology's foundation in the explanation of the Scriptures.

Theology to him was essentially explaining, understanding Scripture; or we might also say that his theology was a perfect symbiosis between theology and exegesis. In fact, the proper hallmark of Origen's doctrine seems to lie precisely in the constant invitation to move from the letter to the spirit of the Scriptures, to progress in knowledge of God. Furthermore, this so-called "allegorism," as von Balthasar wrote,

coincides exactly "with the development of Christian dogma, effected by the teaching of the Church Doctors," who in one way or another accepted Origen's "lessons."

Thus, Tradition and the Magisterium, the foundation and guarantee of theological research, come to take the form of "Scripture in action" (cf. *Origene: Il mondo, Cristo e la Chiesa*, Milan, 1972, p. 43). We can therefore say that the central nucleus of Origen's immense literary opus consists in his "threefold interpretation" of the Bible.

But before describing this "interpretation" it would be right to take an overall look at the Alexandrian's literary production.

St. Jerome, in his *Epistle* 33, lists the titles of 320 books and 310 homilies by Origen. Unfortunately, most of these works have been lost, but even the few that remain make him the most prolific author of Christianity's first three centuries. His field of interest extended from exegesis to dogma, to philosophy, apologetics, ascetical theology and mystical theology. It was a fundamental and global vision of Christian life.

The inspiring nucleus of this work, as we have said, was the "three-fold interpretation" of the Scriptures that Origen developed in his lifetime. By this phrase, we wish to allude to the three most important ways in which Origen devoted himself to studying the Scriptures: they are not in sequence; on the contrary, more often than not they overlap.

First of all, he read the Bible, determined to do his utmost to ascertain the biblical text and offer the most reliable version of it. This, for example, was the first step: to know truly what is written and what a specific scriptural passage intentionally and principally meant.

He studied extensively for this purpose and drafted an edition of the Bible with six parallel columns, from left to right, with the Hebrew text in Hebrew characters — he was even in touch with rabbis to make sure he properly understood the Bible's original Hebrew text — then, the Hebrew text transliterated into Greek characters, and then four different translations in Greek that enabled him to compare the different

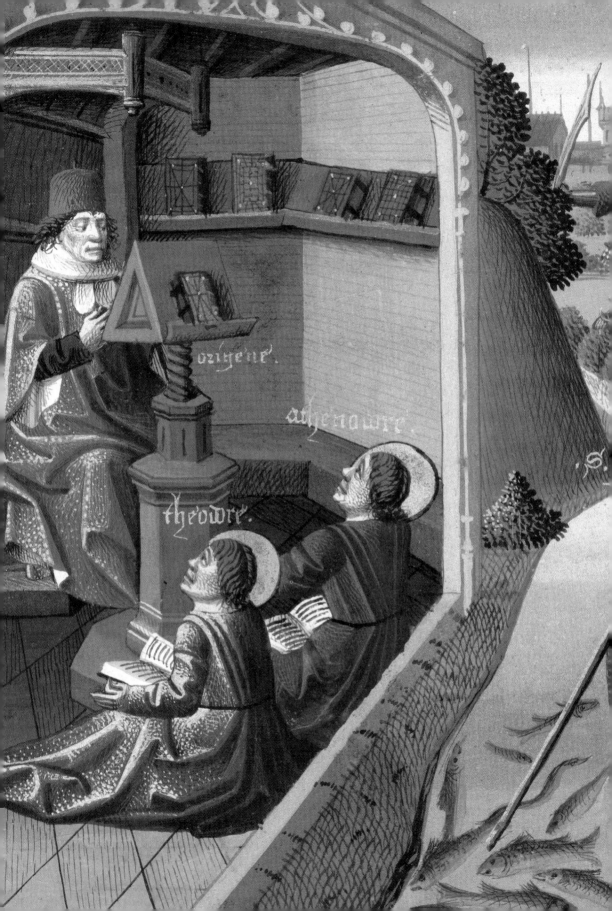

origene

athenodre

theodore

possibilities for its translation. Hence comes the title of *"Hexapla"* (six columns), attributed to this enormous synopsis.

This is the first point: to know exactly what was written — the text as such.

Secondly, Origen read the Bible systematically with his famous *Commentaries.* They reproduced faithfully the explanations that the teacher offered during his lessons at Alexandria and Caesarea.

Origen proceeded verse by verse with a detailed, broad, and analytical approach, with philological and doctrinal notes. He worked with great precision in order to know completely what the sacred authors meant.

Lastly, even before his ordination to the priesthood, Origen was deeply dedicated to preaching the Bible and adapted himself to a varied public. In any case, the teacher can also be perceived in his *Homilies,* wholly dedicated as he was to the systematic interpretation of the passage under examination, which he analyzed step by step in the sequence of the verses.

Also in his *Homilies,* Origen took every opportunity to recall the different dimensions of the sense of Sacred Scripture that encourage or express a process of growth in the faith: there is the "literal" sense, but this conceals depths that are not immediately apparent.

The second dimension is the "moral" sense: what we must do in living the word; and finally, the "spiritual" sense, the unity of Scripture which throughout its development speaks of Christ.

It is the Holy Spirit who enables us to understand the Christological content; hence, the unity in diversity of Scripture. It would be interesting to demonstrate this. I have made a humble attempt in my book, *Jesus of Nazareth,* to show in today's context these multiple dimensions of the Word, of Sacred Scripture, whose historical meaning must in the first place be respected.

But this sense transcends us, moving us toward God in the light of the Holy Spirit, and shows us the way, shows us how to live. Mention of it is found, for example, in the ninth *Homily on Numbers,* where Origen

Origen in His Chair, miniature from the *Mirror of History* by Vincent de Beauvais, Paris, National Library of France, ms. Fr 51, f. 27v

likens Scripture to [fresh] walnuts: "The doctrine of the Law and the Prophets at the school of Christ is like this," the homilist says; "the letter is bitter, like the [green-covered] skin; secondly, you will come to the shell, which is the moral doctrine; thirdly, you will discover the meaning of the mysteries, with which the souls of the saints are nourished in the present life and the future" (*Hom. Num.* 9, 7).

It was especially on this route that Origen succeeded in effectively promoting the "Christian interpretation" of the Old Testament, brilliantly countering the challenge of the heretics, especially the Gnostics and Marcionites, who made the two Testaments disagree to the extent that they rejected the Old Testament.

In this regard, in the same *Homily on Numbers,* the Alexandrian says, "I do not call the Law an 'Old Testament' if I understand it in the Spirit. The Law becomes an 'Old Testament' only for those who wish to understand it carnally," that is, for those who close themselves to the literal meaning of the text.

But "for us, who understand it and apply it in the Spirit and in the Gospel sense, the Law is ever new and the two Testaments are a new Testament for us, not because of their date in time but because of the newness of the meaning.... Instead, for the sinner and those who do not respect the covenant of love, even the Gospels age" (*Homily on Numbers*, 9, 4).

I invite you — and so I conclude — to welcome into your hearts the teaching of this great master of faith. He reminds us with deep delight that in the prayerful reading of Scripture and in consistent commitment to life, the Church is ever renewed and rejuvenated. The Word of God, which never ages and is never exhausted, is a privileged means to this end. Indeed, it is the Word of God, through the action of the Holy Spirit, which always guides us to the whole truth (cf. Benedict XVI, *Address at the International Congress for the 50th Anniversary of* Dei Verbum, *L'Osservatore Romano* English edition, September 21, 2005, p. 7).

And let us pray to the Lord that he will give us thinkers, theologians, and exegetes who discover this multifaceted dimension, this ongoing timeliness of Sacred Scripture, its newness for today. Let us pray that

the Lord will help us to read Sacred Scripture in a prayerful way, to be truly nourished with the true Bread of Life, with his Word.

Teachings[2]

We have examined the life and literary opus of the great Alexandrian teacher, identifying his threefold interpretation of the Bible as the life-giving nucleus of all his work. I now take up two aspects of Origenian doctrine which I consider among the most important and timely: I intend to speak of his teachings on prayer and the Church.

In fact, Origen — author of an important and ever timely *Treatise on Prayer* — constantly interweaves his exegetical and theological writings with experiences and suggestions connected with prayer.

Notwithstanding all the theological richness of his thought, his is never a purely academic approach; it is always founded on the experience of prayer, of contact with God. Indeed, to his mind, knowledge of the Scriptures requires prayer and intimacy with Christ even more than study.

He was convinced that the best way to become acquainted with God is through love, and that there is no authentic *scientia Christi* without falling in love with him.

In his *Letter to Gregory,* Origen recommends: "Study first of all the *lectio* of the divine Scriptures. Study them, I say. For we need to study the divine writings deeply… and while you study these divine works with a believing and God-pleasing intention, knock at that which is closed in them and it shall be opened to you by the porter, of whom Jesus says, 'To him the gatekeeper opens.'

"While you attend to this *lectio divina*, seek aright and with unwavering faith in God the hidden sense which is present in most passages of the divine Scriptures. And do not be content with knocking and seeking, for what is absolutely necessary for understanding divine things is *oratio,* and in urging us to this the Savior says not only 'knock and it

[2] Pope Benedict XVI, General Audience, May 2, 2007.

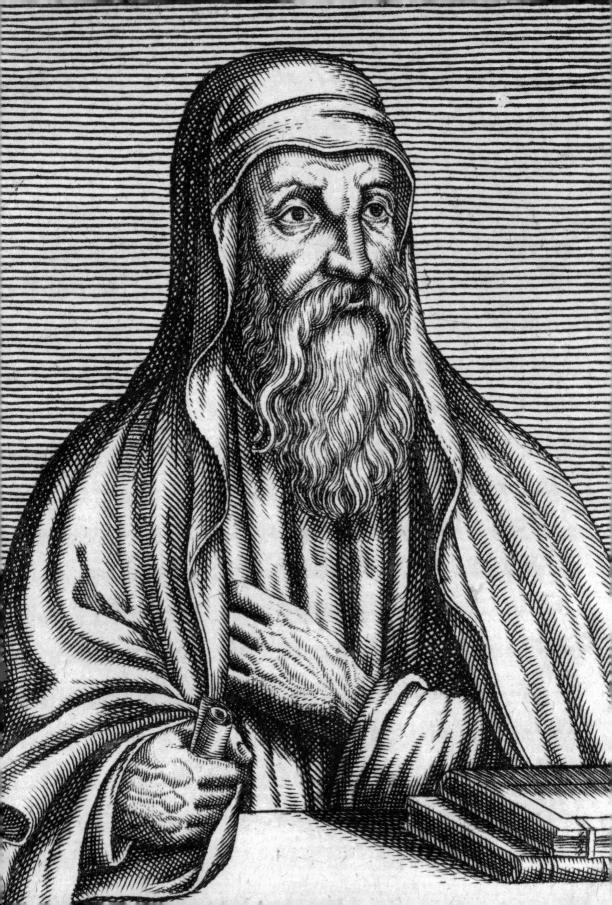

will be opened to you,' and 'seek and you will find,' but also 'ask and it will be given you'" (*Ep. Gr.* 4).

The *"primordial role"* played by Origen in the history of *lectio divina* instantly flashes before one's eyes. Bishop Ambrose of Milan, who learned from Origen's works to interpret the Scriptures, later introduced them into the West to hand them on to Augustine and to the monastic tradition that followed.

As we have already said, according to Origen the highest degree of knowledge of God stems from love. Therefore, this also applies for human beings: only if there is love, if hearts are opened, can one person truly know the other.

Origen based his demonstration of this on a meaning that is sometimes attributed to the Hebrew verb *to know*; that is, when it is used to express the human act of love: "Adam knew Eve his wife, and she conceived" (Gen 4:1).

This suggests that union in love procures the most authentic knowledge. Just as the man and the woman are "two in one flesh," so God and the believer become "two in one spirit."

The prayer of the Alexandrian thus attained the loftiest levels of mysticism, as is attested to by his *Homilies on the Song of Songs*. A passage is presented in which Origen confessed: "I have often felt — God is my witness — that the Bridegroom came to me in the most exalted way. Then he suddenly left, and I was unable to find what I was seeking. Once again, I am taken by the desire for his coming and sometimes he returns, and when he has appeared to me, when I hold him with my hands, once again he flees from me, and when he has vanished I start again to seek him..." (*Hom. in Cant.* 1, 7).

I remember what my venerable predecessor wrote as an authentic witness in *Novo Millennio Ineunte*, where he showed the faithful "how prayer can progress, as a genuine dialogue of love, to the point of render-

Origen, engraving, from André Thévet, *History of the Many Illustrious and Scholarly Men of Their Centuries*, Paris 1671

59

ing the person wholly possessed by the divine Beloved, vibrating at the Spirit's touch, resting filially within the Father's heart."

"It is," John Paul II continues, "a journey totally sustained by grace, which nonetheless demands an intense spiritual commitment and is no stranger to painful purifications.... But it leads, in various possible ways, to the ineffable joy experienced by mystics as 'nuptial union'" (N. 33).

Finally, we come to one of Origen's teachings on the Church, and precisely — within it — on the common priesthood of the faithful. In fact, as the Alexandrian affirms in his ninth *Homily on Leviticus,* "This discourse concerns us all" (*Hom. in Lev.* 9, 1). In the same *Homily,* Origen, referring to Aaron's prohibition, after the death of his two sons, from entering the *Sancta sanctorum* "at all times" (Lev 16:2), thus warned the faithful: "This shows that if anyone were to enter the sanctuary at any time without being properly prepared and wearing priestly attire, without bringing the prescribed offerings and making himself favorable to God, he would die....

"This discourse concerns us all. It requires us, in fact, to know how to accede to God's altar. Oh, do you not know that the priesthood has been conferred upon you too — that is, upon the entire Church of God and believing people? Listen to how Peter speaks to the faithful: 'chosen race,' he says, 'royal, priestly, holy nation, people whom God has ransomed.'

"You therefore possess the priesthood because you are 'a priestly race' and must thus offer the sacrifice to God.... But to offer it with dignity, you need garments that are pure and different from the common clothes of other men, and you need the divine fire" (*Homily on Leviticus*).

Thus, on the one hand, "girded" and in "priestly attire" mean purity and honesty of life, and on the other, with the "lamp ever alight," that is, faith and knowledge of the Scriptures, we have the indispensable conditions for the exercise of the universal priesthood, which demands purity and an honest life, faith, and knowledge of the Scriptures.

For the exercise of the ministerial priesthood, there is of course all the more reason why such conditions should be indispensable.

These conditions — a pure and virtuous life, but above all the acceptance and study of the Word — establish a true and proper "hierarchy of holiness" in the common priesthood of Christians. At the peak of this ascent of perfection, Origen places martyrdom.

Again, in his ninth *Homily on Leviticus,* he alludes to the "fire for the holocaust," that is, to faith and knowledge of the Scriptures which must never be extinguished on the altar of the person who exercises the priesthood.

He then adds: "But each one of us has within him" not only the fire; he "also has the holocaust and from his holocaust lights the altar so that it may burn for ever. If I renounce all my possessions, take up my cross and follow Christ, I offer my holocaust on the altar of God; and if I give up my body to be burned with love and achieve the glory of martyrdom, I offer my holocaust on the altar of God" (*Homily on Leviticus*, 9, 9).

This tireless journey to perfection "concerns us all," in order that "the gaze of our hearts" may turn to contemplate Wisdom and Truth, which are Jesus Christ. Preaching on Jesus' discourse in Nazareth — when "the eyes of all in the synagogue were fixed on him" (cf. Lk 4:16–30) — Origen seems to be addressing us: "Today, too, if you so wished, in this assembly your eyes can be fixed on the Savior.

"In fact, it is when you turn the deepest gaze of your heart to the contemplation of Wisdom, Truth, and the only Son of God that your eyes will see God. Happy the assembly of which Scripture attests that the eyes of all were fixed upon him!

"How I would like this assembly here to receive a similar testimony, and the eyes of all — the non-baptized and the faithful, women, men, and children — to look at Jesus, not the eyes of the body but those of the soul!...

"Impress upon us the light of your face, O Lord, to whom be the power and the glory for ever and ever. Amen!" (*Homily on Luke*).

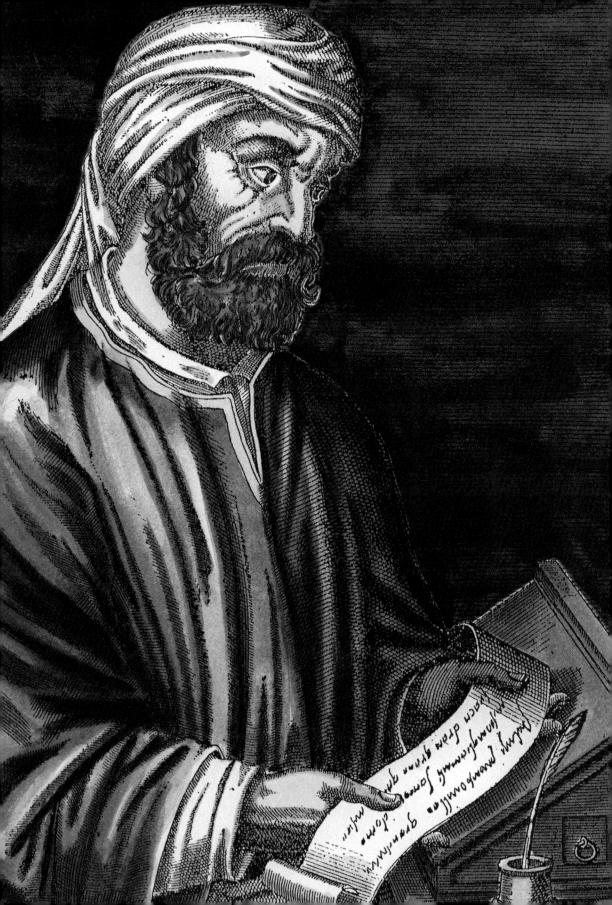

Tertullian[1]

We continue to speak of the ancient Church's great personalities. They are teachers of the faith also for us today and witnesses of the perennial timeliness of the Christian faith.

Now, we speak of an African, Tertullian, who from the end of the second and beginning of the third centuries inaugurated Christian literature in the Latin language. He started the use of theology in Latin. His work brought decisive benefits which it would be unforgivable to underestimate. His influence covered different areas: linguistically, from the use of language and the recovery of classical culture, to singling out a common "Christian soul" in the world and in the formulation of new proposals of human coexistence.

We do not know the exact dates of his birth and death. Instead, we know that at Carthage, toward the end of the second century, he received a solid education in rhetoric, philosophy, history, and law from his pagan parents and tutors. He then converted to Christianity, attracted, so it seems, by the example of the Christian martyrs.

He began to publish his most famous writings in 197. But a too individualistic search for the truth, together with his intransigent character

[1] Pope Benedict XVI, General Audience, May 30, 2007.

Tertullian, engraving with watercolors

— he was a rigorous man — gradually led him away from communion with the Church to belong to the Montanist sect. The originality of his thought, however, together with an incisive efficacy of language, assured him a high position in ancient Christian literature.

His apologetic writings are above all the most famous. They manifest two key intentions: to refute the grave accusations that pagans directed against the new religion; and, more propositional and missionary, to proclaim the Gospel message in dialogue with the culture of the time.

His most famous work, *Apologeticus,* denounces the unjust behavior of political authorities toward the Church; explains and defends the teachings and customs of Christians; spells out differences between the new religion and the main philosophical currents of the time; and manifests the triumph of the Spirit that counters its persecutors with the blood, suffering, and patience of the martyrs: "Refined as it is," the African writes, "your cruelty serves no purpose. On the contrary, for our community, it is an invitation. We multiply every time one of us is mowed down. The blood of Christians is effective seed" (*"Semen est sanguis christianorum!" Apologeticus,* 50:13).

Martyrdom, suffering for the truth, is in the end victorious and more efficient than the cruelty and violence of totalitarian regimes.

But Tertullian, as every good apologist, at the same time sensed the need to positively communicate the essence of Christianity. This is why he adopted the speculative method to illustrate the rational foundations of Christian dogma. He developed it in a systematic way, beginning with the description of "the God of the Christians": "He whom we adore," the Apologist wrote, "is the one, only God." And he continued, using antitheses and paradoxes characteristic of his language: "He is invisible, even if you see him, difficult to grasp, even if he is present through grace; inconceivable even if the human senses can perceive him, therefore, he is true and great!" (cf. *Apologeticus,* 17:1-2).

Furthermore, Tertullian takes an enormous step in the development of Trinitarian dogma. He has given us an appropriate way to express

this great mystery in Latin by introducing the terms "one substance" and "three Persons." In a similar way, he also greatly developed the correct language to express the mystery of Christ, Son of God and true Man.

The Holy Spirit is also considered in the African's writings, demonstrating his personal and divine character: "We believe that, according to his promise, Jesus Christ sent, by means of his Father, the Holy Spirit, the Paraclete, the sanctifier of the faith of all those who believe in the Father, Son, and Holy Spirit" (*Apologeticus*, 2:1).

Again, there are in Tertullian's writings numerous texts on the Church, whom he always recognizes as "mother." Even after his acceptance of *Montanism*, he did not forget that the Church is the Mother of our faith and Christian life.

He even considers the moral conduct of Christians and the future life. His writings are important as they also show the practical trends in the Christian community regarding Mary Most Holy, the Sacraments of the Eucharist, matrimony, and reconciliation, Petrine primacy, prayer.... In a special way, in those times of persecution when Christians seemed to be a lost minority, the apologist exhorted them to hope, which in his treatises is not simply a virtue in itself, but something that involves every aspect of Christian existence.

We have the hope that the future is ours because the future is God's. Therefore, the Lord's Resurrection is presented as the foundation of our future resurrection and represents the main object of the Christian's *confidence*: "And so the flesh shall rise again," the African categorically affirms, "wholly in every man, in its own identity, in its absolute integrity. Wherever it may be, it is in safe keeping in God's presence, through that most faithful Mediator between God and man, Jesus Christ, who shall reconcile both God to man, and man to God" (*Concerning the Resurrection of the Flesh,* 63:1).

From the human viewpoint one can undoubtedly speak of Tertullian's own drama. With the passing of years he became increasingly

exigent in regard to the Christians. He demanded heroic behavior from them in every circumstance, above all under persecution.

Rigid in his positions, he did not withhold blunt criticism and he inevitably ended by finding himself isolated.

Besides, many questions still remain open today, not only on Tertullian's theological and philosophical thought, but also on his attitude in regard to political institutions and pagan society.

This great moral and intellectual personality, this man who made such a great contribution to Christian thought, makes me think deeply. One sees that in the end he lacked the simplicity, the humility, to integrate himself with the Church, to accept his weaknesses, to be forbearing with others and himself.

When one only sees his thought in all its greatness, in the end, it is precisely this greatness that is lost. The essential characteristic of a great theologian is the humility to remain with the Church, to accept his own and others' weaknesses, because actually only God is all holy. We, instead, always need forgiveness.

Finally, the African remains an interesting witness of the early times of the Church, when Christians found they were the authentic protagonists of a "new culture" in the critical confrontation between the classical heritage and the Gospel message.

In his famous affirmation according to which our soul "is *naturally* Christian" (*Apologeticus* 17:6), Tertullian evokes the perennial continuity between authentic human values and Christian ones. Also in his other reflection borrowed directly from the Gospel, according to which "the Christian cannot hate, not even his enemies" (cf. *Apologeticus* 37), is found the unavoidable moral resolve, the choice of faith which proposes "non-violence" as the rule of life. Indeed, no one can escape the dramatic aptness of this teaching, also in light of the heated debate on religions.

In summary, the treatises of this African trace many themes that we are still called to face today. They involve us in a fruitful interior exami-

nation to which I exhort all the faithful, so that they may know how to express in an always more convincing manner the *Rule of Faith,* which — again, referring to Tertullian — "prescribes the belief that there is only one God and that he is none other than the Creator of the world, who produced all things out of nothing through his own Word, generated before all things" (cf. *Concerning the Prescription of Heretics,* 13: 1).

St. Cyprian[1]

In our catecheses on the great figures of the ancient Church, we come to an excellent African bishop of the third century, St. Cyprian, "the first Bishop in Africa to obtain the crown of martyrdom."

His fame, Pontius the Deacon his first biographer attests, is also linked to his literary corpus and pastoral activity during the thirteen years between his conversion and his martyrdom (cf. *Life and Passion of St. Cyprian,* 19, 1; 1, 1).

Cyprian was born in Carthage into a rich pagan family. After a dissipated youth, he converted to Christianity at the age of thirty-five.

He himself often told of his spiritual journey, "When I was still lying in darkness and gloomy night," he wrote a few months after his baptism, "I used to regard it as extremely difficult and demanding to do what God's mercy was suggesting to me. I myself was held in bonds by the innumerable errors of my previous life, from which I did not believe I could possibly be delivered, so I was disposed to acquiesce in my clinging vices and to indulge my sins....

"But after that, by the help of the water of new birth, the stain of my former life was washed away, and a light from above, serene and

[1] Pope Benedict XVI, General Audience, June 6, 2007.

Paolo Veronese, *St. Anthony with Sts. Cornelius and Cyprian,* Milan (Italy), Pinacoteca di Brera

pure, was infused into my reconciled heart… a second birth restored me to a new man. Then, in a wondrous manner every doubt began to fade.… I clearly understood that what had first lived within me, enslaved by the vices of the flesh, was earthly and that what, instead, the Holy Spirit had wrought within me was divine and heavenly" (*Ad Donatum,* 3–4).

Immediately after his conversion, despite envy and resistance, Cyprian was chosen for the priestly office and raised to the dignity of bishop. In the brief period of his episcopacy he had to face the first two persecutions sanctioned by imperial decree: that of Decius (250) and that of Valerian (257–258).

After the particularly harsh persecution of Decius, the bishop had to work strenuously to restore order to the Christian community. Indeed, many of the faithful had abjured or at any rate had not behaved correctly when put to the test. They were the so-called *lapsi* — that is, the "fallen" — who ardently desired to be readmitted to the community.

The debate on their readmission actually divided the Christians of Carthage into laxists and rigorists. These difficulties were compounded by a serious epidemic of the plague which swept through Africa and gave rise to anguished theological questions both within the community and in the confrontation with pagans. Lastly, the controversy between St. Cyprian and Stephen, Bishop of Rome, concerning the validity of baptism administered to pagans by heretical Christians, must not be forgotten.

In these truly difficult circumstances, Cyprian revealed his choice gifts of government: he was severe but not inflexible with the *laxists,* granting them the possibility of forgiveness after exemplary repentance. Before Rome, he staunchly defended the healthy traditions of the African Church; he was deeply human and steeped with the most authentic Gospel spirit when he urged Christians to offer brotherly assistance to pagans during the plague; he knew how to maintain the proper balance

Maestro di Meßkirch, *St. Cyprian*, Meßkirch (Germany), Church of St. Martin

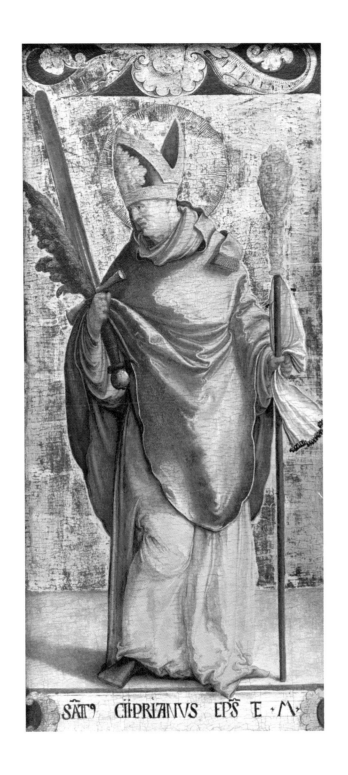

SAT⁹ CIPRIANVS EPS E ·M·

when reminding the faithful — excessively afraid of losing their lives and their earthly possessions — that true life and true goods are not those of this world; he was implacable in combating corrupt morality and the sins that devastated moral life, especially avarice.

"Thus he spent his days," Pontius the Deacon tells at this point, "when at the bidding of the proconsul, the officer with his soldiers all of a sudden came unexpectedly upon him in his grounds" (*Life and Passion of St. Cyprian,* 15, 1).

On that day, the holy bishop was arrested and after being questioned briefly, courageously faced martyrdom in the midst of his people.

The numerous treatises and letters that Cyprian wrote were always connected with his pastoral ministry. Little inclined to theological speculation, he wrote above all for the edification of the community and to encourage the good conduct of the faithful.

Indeed, the Church was easily his favorite subject. Cyprian distinguished between the *visible*, hierarchical *Church* and the *invisible*, mystical *Church* but forcefully affirmed that the Church is one, founded on Peter.

He never wearied of repeating that "if a man deserts the Chair of Peter upon whom the Church was built, does he think that he is in the Church?" (cf. *De Unit. [On the unity of the Catholic Church]*, 4).

Cyprian knew well that "outside the Church there is no salvation," and said so in strong words (*Epistles* 4, 4 and 73, 21); and he knew that "no one can have God as Father who does not have the Church as mother" (*De unit.,* 6). An indispensable characteristic of the Church is unity, symbolized by Christ's seamless garment (*De unit.,* 7). Cyprian said this unity is founded on Peter (*De unit.,* 4), and its perfect fulfillment is in the Eucharist (*Epistle* 63, 13).

"God is one and Christ is one," Cyprian cautioned, "and his Church is one, and the faith is one, and the Christian people are joined into a

Catalan art, *St. Cyprian Conducted before the Emperor Valerian,*
Vic (Spain), Museu Episcopal

73

substantial unity of body by the cement of concord. Unity cannot be severed. And what is one by its nature cannot be separated" (*De Unit.*, 23).

We have spoken of his thought on the Church but, lastly, let us not forget Cyprian's teaching on prayer. I am particularly fond of his treatise on the Our Father, which has been a great help to me in understanding and reciting the Lord's Prayer better.

Cyprian teaches that it is precisely in the Lord's Prayer that the proper way to pray is presented to Christians. And he stresses that this prayer is in the plural in order that "the person who prays it might not pray for himself alone. Our prayer," he wrote, "is public and common; and when we pray, we pray not for one, but for the whole people, because we, the whole people, are one" (*De Dom. Orat. [Treatise on the Lord's Prayer]*, 8).

Thus, personal and liturgical prayer seem to be strongly bound. Their unity stems from the fact that they respond to the same Word of God. The Christian does not say "*my* Father" but "*our* Father," even in the secrecy of a closed room, because he knows that in every place, on every occasion, he is a member of one and the same Body.

"Therefore let us pray, beloved Brethren," the Bishop of Carthage wrote, "as God our Teacher has taught us. It is a trusting and intimate prayer to beseech God with his own word, to raise to his ears the prayer of Christ. Let the Father acknowledge the words of his Son when we pray, and let him also who dwells within our breast himself dwell in our voice....

"But let our speech and petition when we pray be under discipline, observing quietness and modesty. Let us consider that we are standing in God's sight. We must please the divine eyes both with the position of the body and with the measure of voice....

"Moreover, when we meet together with the brethren in one place, and celebrate divine sacrifices with God's priest, we ought to be mindful of modesty and discipline — not to throw abroad our prayers indiscriminately, with unsubdued voices, nor to cast to God with tumultuous

wordiness a petition that ought to be commended to God by modesty; for God is the hearer, not of the voice, but of the heart *(non vocis sed cordis auditor est)*" *(De Dom. Orat. [Treatise on the Lord's Prayer]*, 3–4). Today too, these words still apply and help us to celebrate the Holy Liturgy well.

Ultimately, Cyprian placed himself at the root of that fruitful theological and spiritual tradition which sees the "heart" as the privileged place for prayer.

Indeed, in accordance with the Bible and the Fathers, the heart is the intimate depths of man, the place in which God dwells. In it occurs the encounter in which God speaks to man, and man listens to God; man speaks to God and God listens to man. All this happens through one divine Word. In this very sense — re-echoing Cyprian — Smaragdus, Abbot of St. Michael on the Meuse in the early years of the ninth century, attests that prayer "is the work of the heart, not of the lips, because God does not look at the words but at the heart of the person praying" *(Diadema Monachorum [Diadem of the Monks]*, 1).

Dear friends, let us make our own this receptive heart and "understanding mind" of which the Bible (cf. 1 Kings 3:9) and the Fathers speak. How great is our need for it! Only then will we be able to experience fully that God is our Father and that the Church, the holy Bride of Christ, is truly our Mother.

CHAPTER NINE

Eusebius of Caesarea[1]

In the history of early Christianity there is a fundamental distinction between the first three centuries and those that followed the Council of Nicaea in 325, the first Ecumenical Council. Like a "hinge" between the two periods are the so-called "conversion of Constantine" and the peace of the Church, as well as the figure of Eusebius, Bishop of Caesarea in Palestine. He was the most highly qualified exponent of the Christian culture of his time in very varied contexts, from theology to exegesis, from history to erudition. Eusebius is known above all as the first historian of Christianity, but he was also the greatest philologist of the ancient Church.

It was to Caesarea, where Eusebius was born probably in about the year A.D. 260, that Origen had fled from Alexandria. And in Caesarea, Origen founded a school and a huge library. A few decades later, the young Eusebius educated himself with these books. In 325, as Bishop of Caesarea, he played a lead role at the Council of Nicaea. He signed the Creed and the affirmation of the full divinity of the Son of God, who is consequently defined as "one in being with the Father" (*Homooúsios tō Patrí*). The Creed we recite every Sunday in the Holy Liturgy is practically the same.

[1] Pope Benedict XVI, General Audience, June 13, 2007.

Ammonius and Esebius, miniature from a Syriac Bible, Florence (Italy), Biblioteca Medicea Laurenziana, Ms. Plut. I, 56, f. 2r

A sincere admirer of Constantine who had given peace to the Church, Eusebius in turn was esteemed and respected by Constantine. As well as with his works, Eusebius also celebrated the Emperor with panegyrics which he delivered on the twentieth and thirtieth anniversary of his ascendance to the throne, and upon his death in the year 337. Two or three years later, Eusebius died, too.

Eusebius was an indefatigable scholar. In his numerous writings he resolved to reflect and to give an up-to-date report on the three centuries of Christianity, three centuries lived under persecution, drawing abundantly on the Christian and pagan sources preserved in particular in the great library of Caesarea.

Thus, despite the objective importance of his apologetic, exegetic, and doctrinal works, the imperishable fame of Eusebius is still mainly associated with the ten books of his *Ecclesiastical History*. He was the first person to write a history of the Church which continues to be of fundamental importance, thanks to the sources which Eusebius made available to us forever.

With this chronicle, he succeeded in saving from the doom of oblivion numerous events, important figures, and literary works of the ancient Church. Thus, his work is a primary source of knowledge of the early centuries of Christianity.

We might wonder how he structured this new work and what his intentions were in compiling it. At the beginning of his first book, the historian lists in detail the topics he intends to treat in his work: "It is my purpose to write an account of the succession of the holy Apostles, as well as of the times which have elapsed from the days of our Savior to our own; and to relate the many important events which are said to have occurred in the history of the Church; and to mention those who have governed and presided over the Church in the most prominent dioceses, and those who in each generation have proclaimed the divine Word either orally or in writing.

"It is my purpose also to give the names and number and times of those who through love of innovation have run into the greatest errors, and, proclaiming themselves interpreters and promoters of a false doctrine have, like fierce wolves, unmercifully devastated the flock of Christ... and to record the ways and the times in which the divine word has been attacked by the Gentiles, and to describe the character of the great men who in various periods have defended it in the face of blood and of tortures... and finally, the mercy and benevolence which Our Savior has afforded them all" (*Ecclesiastical History,* cf. I, 1, 1–3).

Thus, Eusebius embraced different spheres: the succession of the Apostles as the backbone of the Church, the dissemination of the Message, the errors and then persecutions on the part of the pagans, and the important testimonies which are the light in this chronicle.

In all this, Eusebius saw the Savior's mercy and benevolence. So it was that he inaugurated, as it were, ecclesiastical historiography, extending his account to 324, the year in which Constantine, after defeating Licinius, was acclaimed as the one Emperor of Rome. This was the year before the important Council of Nicaea, which subsequently offered the "summa" of all that the Church — doctrinally, morally, and also juridically — had learned in the previous 300 years.

The citation we have just quoted from the First Book of the *Ecclesiastical History* contains a repetition that is certainly intentional. The Christological title *Savior* recurs three times in the space of a few lines with an explicit reference to "his mercy" and "his benevolence."

Thus, we can grasp the fundamental perspective of Eusebian historiography: his is a "Christocentric" history, in which the mystery of God's love for humankind is gradually revealed.

Eusebius recognized with genuine amazement that: "Jesus alone of all those who have ever existed is even to the present day called Christ

On pages 80-81: Eusebius, *Evangelary of Feasts, Concordance Table*, Brescia (Italy), Biblioteca Queriniana, Ms. F. II. 1, f. 7v-8r

CANON · VI · INQVO · II ·

ONAT	MAR
XVIII	III
XVII	VII
XX	VIIII
XXII	XI
XLIIII	CXXXVI
LXXXVII	LXXII
LXXXVII	CXXXVIIII
C	XCVIII
CXXXVIII	XLV
CXLII	LV
CXLVII	LXV
CLII	LXVIII
CLIIII	LXXI
CLVII	LXXII
CLVIII	LXXIIII
CLVI	LXXVII
CLXIII	LXXVIII
CLXVI	LXXXII
CLXVIIII	LXXXIII
CLXXV	LXXXVII
CLXXV	CIII
CLXXVIIII	CXVI
CCII	CXX
CCVIII	
CCXX	CXXIIII
CCXXVII	CXXXVI
CCXLVI	CXL
CCXLVII	CXLII
CCL	CXLVI
CCLII	CXLVIII
CCLVII	CXLVIII
CCLX	CLII
CCLXIII	CLIII
CCLXXV	CLVI
CCLXXXV	CLVII
CCLXXXVI	CLXII

CANON · V · INQVO· II·

MAT		LVC
iii		ii
x		xi
xii		xvii
xvi		
		xlvi
xxxv		xlvii
xxxvi		xlvii
xxxviii		xlviii
xxxx		
		cxciiii
xxxiiii		clxvi
xxxvi		liii
xxxviii		lii
xl		
		lv
xli		cxcvii
xlii		cliii
xlvi		cxxxiii
xlvii		
		cxci
xlviii		cl
xlviiii		lviii
liii		cxxxv
liiii		liiii
lv		clxxv
lvii		lxi
		lx
lx		
lxi		clxxi
lxv		lxviii
lxvii		lxxi
lxviii		cv
lxxiii		cvii
lxxviiii		cxii
lxxxvi		cxiii
xciii		cxlv
xcv		clx
xcvi		clxxiii
xcvi		clxxiiii

[that is Messiah and Savior of the world] by all men throughout the world, and is confessed and witnessed to under this name, and is commemorated both by Greeks and Barbarians and even to this day is honored as a King by his followers throughout the world, and is admired as more than a prophet, and is glorified as the true and only High Priest of God. And besides all this, as the pre-existent Logos of God, called into being before all ages, he has received august honor from the Father, and is worshipped and adored as God. But most wonderful of all is the fact that we who have consecrated ourselves to him, honor him not only with our voices and with the sound of words, but also with complete elevation of soul, so that we choose to give testimony unto him rather than to preserve our own lives" (*Ecclesiastical History*, cf. I, 3, 19–20).

Another feature thus springs to the fore which was to remain a constant in ancient ecclesiastical historiography: it is the "moral intention" that presides in the account. Historical analysis is never an end in itself; it is not made solely with a view to knowing the past; rather, it focuses decisively on conversion and on an authentic witness of Christian life on the part of the faithful. It is a guide for us, too.

Thus, Eusebius strongly challenges believers of all times on their approach to the events of history and of the Church in particular. He also challenges us: what is our attitude with regard to the Church's experiences? Is it the attitude of those who are interested in it merely out of curiosity, or even in search of something sensational or shocking at all costs? Or is it an attitude full of love and open to the mystery of those who know — through faith — that they can trace in the history of the Church those signs of God's love and the great works of salvation wrought by him?

If this is our attitude, we can only feel stimulated to a more coherent and generous response, to a more Christian witness of life, in order to bequeath the signs of God's love also to the generations to come.

"There is a mystery," Cardinal Jean Daniélou, an eminent Patristics scholar, never tired of saying. "History has a hidden content.... The

mystery is that of God's works which constitute in time the authentic reality concealed behind the appearances.... However, this history which he brings about for man, God does not bring about without him.

"Pausing to contemplate the 'great things' worked by God would mean seeing only one aspect of things. The human response lies before them" (*Saggio sul Mistero della Storia,* Italian edition, Brescia, 1963, p. 182).

Today, too, so many centuries later, Eusebius of Caesarea invites believers, invites us, to wonder, to contemplate in history the great works of God for the salvation of humankind. And just as energetically, he invites us to conversion of life. Indeed, we cannot remain inert before a God who has so deeply loved us. The proper instance of love is that our entire life should be oriented to the imitation of the Beloved. Let us therefore spare no effort to leave a transparent trace of God's love in our life.

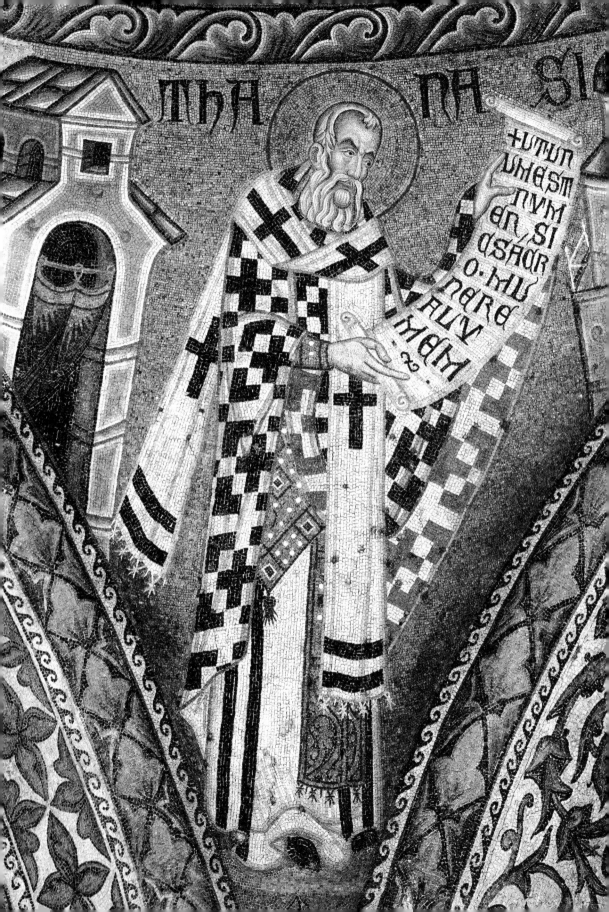

St. Athanasius of Alexandria[1]

Continuing our revisitation of the great Teachers of the ancient Church, let us now focus our attention on St. Athanasius of Alexandria.

Only a few years after his death, this authentic protagonist of the Christian tradition was already hailed as "the pillar of the Church" by Gregory of Nazianzus, the great theologian and Bishop of Constantinople (*Orationes,* 21, 26), and he has always been considered a model of orthodoxy in both East and West.

As a result, it was not by chance that Gian Lorenzo Bernini placed his statue among those of the four holy Doctors of the Eastern and Western Churches — together with the images of Ambrose, John Chrysostom, and Augustine — which surround the Chair of St. Peter in the marvelous apse of the Vatican Basilica.

Athanasius was undoubtedly one of the most important and revered early Church Fathers. But this great saint was above all the impassioned theologian of the Incarnation of the *Logos,* the Word of God who — as the Prologue of the fourth Gospel says — "became flesh and dwelt among us" (Jn 1:14).

[1] Pope Benedict XVI, General Audience, June 20, 2007.

St. Athanasius, mosaic, Venice (Italy), Basilica of San Marco

For this very reason Athanasius was also the most important and tenacious adversary of the Arian heresy, which at that time threatened faith in Christ, reduced to a creature "halfway" between God and man, according to a recurring tendency in history which we also see manifested today in various forms.

In all likelihood Athanasius was born in Alexandria, Egypt, in about the year A.D. 300. He received a good education before becoming a deacon and secretary to the Bishop of Alexandria, the great Egyptian metropolis. As a close collaborator of his bishop, the young cleric took part with him in the Council of Nicaea, the first Ecumenical Council, convoked by the Emperor Constantine in May A.D. 325 to ensure Church unity. The Nicene Fathers were thus able to address various issues and primarily the serious problem that had arisen a few years earlier from the preaching of the Alexandrian priest Arius.

With his theory, Arius threatened authentic faith in Christ, declaring that the *Logos* was not a true God but a created God, a creature "halfway" between God and man who hence remained forever inaccessible to us. The bishops gathered in Nicaea responded by developing and establishing the "Symbol of Faith" [Creed] which, completed later at the First Council of Constantinople, has endured in the traditions of various Christian denominations and in the liturgy as the *Niceno-Constantinopolitan Creed.*

In this fundamental text — which expresses the faith of the undivided Church and which we also recite today, every Sunday, in the Eucharistic celebration — the Greek term *homoousios* is featured, in Latin *consubstantialis:* it means that the Son, the *Logos,* is "of the same substance" as the Father, he is God of God, he is his substance. Thus, the full divinity of the Son, which was denied by the Arians, was brought into the limelight.

In A.D. 328, when Bishop Alexander died, Athanasius succeeded him as Bishop of Alexandria. He immediately showed that he was determined to reject any compromise with regard to the Arian theories condemned by the Council of Nicaea.

His intransigence — tenacious and, if necessary, at times harsh — against those who opposed his episcopal appointment and especially against adversaries of the Nicene Creed, provoked the implacable hostility of the Arians and philo-Arians.

Despite the unequivocal outcome of the Council, which clearly affirmed that the Son is of the same substance as the Father, these erroneous ideas shortly thereafter once again began to prevail — in this situation even Arius was rehabilitated — and they were upheld for political reasons by the Emperor Constantine himself and then by his son Constantius II.

Moreover, Constantine was not so much concerned with theological truth but rather with the unity of the Empire and with its political problems; he wished to politicize the faith, making it more accessible — in his opinion — to all his subjects throughout the Empire.

Thus, the Arian crisis, believed to have been resolved at Nicaea, persisted for decades with complicated events and painful divisions in the Church. At least five times — during the thirty years between A.D. 336 and 366 — Athanasius was obliged to abandon his city, spending seventeen years in exile and suffering for the faith. But during his forced absences from Alexandria, the bishop was able to sustain and to spread in the West, first at Trier and then in Rome, the Nicene faith as well as the ideals of monasticism, embraced in Egypt by the great hermit Anthony, with a choice of life to which Athanasius was always close.

St. Anthony, with his spiritual strength, was the most important champion of St. Athanasius's faith. Reinstated in his See once and for all, the Bishop of Alexandria was able to devote himself to religious pacification and the reorganization of the Christian communities. He died on May 2, 373, the day when we celebrate his liturgical Memorial.

The most famous doctrinal work of the holy Alexandrian bishop is his treatise *De Incarnatione* on the Incarnation of the Word, the divine *Logos* who was made flesh, becoming like one of us for our salvation.

In this work Athanasius says with an affirmation that has rightly become famous that the Word of God "was made man so that we might

be made God; and he manifested himself through a body so that we might receive the idea of the unseen Father; and he endured the insolence of men that we might inherit immortality" (*De Incarnatione,* 54, 3). With his Resurrection, in fact, the Lord banished death from us like "straw from the fire" (*De Incarnatione*, 8, 4).

The fundamental idea of Athanasius's entire theological battle was precisely that God is accessible. He is not a secondary God, he is the true God and it is through our communion with Christ that we can truly be united to God. He has really become "God-with-us."

Among the other works of this great Father of the Church — which remain largely associated with the events of the Arian crisis — let us remember the four epistles he addressed to his friend Serapion, Bishop of Thmuis, on the divinity of the Holy Spirit which he clearly affirmed, and approximately thirty "Festal" Letters addressed at the beginning of each year to the Churches and monasteries of Egypt to inform them of the date of the Easter celebration, but above all to guarantee the links between the faithful, reinforcing their faith and preparing them for this great Solemnity.

Lastly, Athanasius also wrote meditational texts on the Psalms, subsequently circulated widely, and in particular, a work that constitutes the *bestseller* of early Christian literature*: The Life of Anthony* — that is, the biography of St. Anthony Abbot. It was written shortly after this saint's death precisely while the exiled Bishop of Alexandria was staying with monks in the Egyptian desert.

Athanasius was such a close friend of the great hermit that he received one of the two sheepskins which Anthony left as his legacy, together with the mantle that the Bishop of Alexandria himself had given to him.

The exemplary biography of this figure dear to Christian tradition soon became very popular, almost immediately translated into Latin, in two editions, and then into various Oriental languages; it made an important contribution to the spread of monasticism in the East and in the West.

It was not by chance that the interpretation of this text, in Trier, was at the center of a moving tale of the conversion of two imperial officials which Augustine incorporated into his *Confessions* (cf. VIII, 6, 15) as the preamble to his own conversion.

Moreover, Athanasius himself showed he was clearly aware of the influence that Anthony's fine example could have on Christian people. Indeed, he wrote at the end of this work: "The fact that his fame has been blazoned everywhere, that all regard him with wonder, and that those who have never seen him long for him, is clear proof of his virtue and God's love of his soul. For not from writings, nor from worldly wisdom, nor through any art, was Anthony renowned, but solely from his piety toward God. That this was the gift of God no one will deny.

"For from whence into Spain and into Gaul, how into Rome and Africa, was the man heard of who dwelt hidden in a mountain, unless it was God who makes his own known everywhere, who also promised this to Anthony at the beginning? For even if they work secretly, even if they wish to remain in obscurity, yet the Lord shows them as lamps to lighten all, that those who hear may thus know that the precepts of God are able to make men prosper and thus be zealous in the path of virtue" (*Life of Anthony*, 93, 5–6).

Yes, brothers and sisters! We have many causes for which to be grateful to St. Athanasius. His life, like that of Anthony and of countless other saints, shows us that "those who draw near to God do not withdraw from men, but rather become truly close to them" (*Deus Caritas Est*, n. 42).

On pages 90–91: Giorgio Vasari/Federico Zuccari, *Universal Judgment*, Florence (Italy), cupola of Church of Santa Maria del Fiore

St. Cyril of Jerusalem[1]

O ur attention now is focused on St. Cyril of Jerusalem. His life is woven of two dimensions: on the one hand, pastoral care; and on the other, his involvement, in spite of himself, in the heated controversies that were then tormenting the Church of the East.

Cyril was born at or near Jerusalem in A.D. 315. He received an excellent literary education which formed the basis of his ecclesiastical culture, centered on study of the Bible. He was ordained a priest by Bishop Maximus.

When this bishop died or was deposed in 348, Cyril was ordained a bishop by Acacius, the influential Metropolitan of Caesarea in Palestine, a philo-Arian who must have been under the impression that in Cyril he had an ally. So as a result Cyril was suspected of having obtained his episcopal appointment by making concessions to Arianism.

Actually, Cyril very soon came into conflict with Acacius, not only in the field of doctrine but also in that of jurisdiction, because he claimed his own See to be autonomous from the Metropolitan See of Caesarea.

[1] Pope Benedict XVI, General Audience, June 27, 2007.

St. Cyril, Bishop of Jerusalem, and St. Augustine, miniature, Ecouen (France), Musée National de la Renaissance

Cyril was exiled three times within the course of approximately twenty years: the first time was in 357, after being deposed by a Synod of Jerusalem; followed by a second exile in 360, instigated by Acacius; and finally, in 367, by a third exile — his longest, which lasted eleven years — by the philo-Arian Emperor Valens.

It was only in 378, after the Emperor's death, that Cyril could definitively resume possession of his See and restore unity and peace to his faithful.

Some sources of that time cast doubt on his orthodoxy, whereas other equally ancient sources come out strongly in his favor. The most authoritative of them is the Synodal Letter of 382 that followed the Second Ecumenical Council of Constantinople (381), in which Cyril had played an important part.

In this letter addressed to the Roman Pontiff, the Eastern Bishops officially recognized Cyril's flawless orthodoxy, the legitimacy of his episcopal ordination, and the merits of his pastoral service, which ended with his death in 387.

Of Cyril's writings, twenty-four famous catecheses have been preserved, which he delivered as bishop in about 350.

Introduced by a *Procatechesis* of welcome, the first eighteen of these are addressed to catechumens or candidates for illumination (*photizomenoi)* [candidates for baptism]; they were delivered in the Basilica of the Holy Sepulcher. Each of the first ones (nn. 1–5) respectively treat the prerequisites for baptism, conversion from pagan morals, the Sacrament of baptism, and the ten dogmatic truths contained in the Creed or Symbol of the Faith.

The next catecheses (nn. 6–18) form an "ongoing catechesis" on the Jerusalem Creed in anti-Arian tones.

Of the last five so-called "mystagogical catecheses," the first two develop a commentary on the rites of baptism and the last three focus on the Chrism, the Body and Blood of Christ, and the Eucharistic Liturgy. They include an explanation of the Our Father (*Oratio dominica*).

This forms the basis of a process of initiation to prayer which develops on a par with the initiation to the three Sacraments of baptism, confirmation, and the Eucharist.

The basis of his instruction on the Christian faith also served to play a polemic role against pagans, Judaeo Christians, and Manicheans. The argument was based on the fulfillment of the Old Testament promises, in a language rich in imagery.

Catechesis marked an important moment in the broader context of the whole life — particularly liturgical — of the Christian community, in whose maternal womb the gestation of the future faithful took place, accompanied by prayer and the witness of the brethren.

Taken as a whole, Cyril's homilies form a systematic catechesis on the Christian's rebirth through baptism.

He tells the catechumen: "You have been caught in the nets of the Church (cf. Mt 13:47). Be taken alive, therefore; do not escape, for it is Jesus who is fishing for you, not in order to kill you but to resurrect you after death. Indeed, you must die and rise again... (cf. Rom 6:11, 14). Die to your sins and live to righteousness from this very day" (*Procatechesis*, 5).

From the *doctrinal* viewpoint, Cyril commented on the Jerusalem Creed with recourse to the typology of the Scriptures in a "symphonic" relationship between the two Testaments, arriving at Christ, the center of the universe.

The typology was to be described decisively by Augustine of Hippo: "In the Old Testament there is a veiling of the New, and in the New Testament there is a revealing of the Old" (*De Catechizandis Rudibus* 4, 8).

As for the *moral* catechesis, it is anchored in deep unity to the doctrinal catechesis: the dogma progressively descends in souls who are thus urged to transform their pagan behavior on the basis of new life in Christ, a gift of baptism.

On pages 96–97: Sano di Pietro, *St. Jerome Appearing to St. Cyril of Jerusalem,* Paris, Louvre museum

The "mystagogical" catechesis, lastly, marked the summit of the instruction that Cyril imparted, no longer to catechumens but to the newly baptized or neophytes during Easter week. He led them to discover the mysteries still hidden in the baptismal rites of the Easter Vigil.

Enlightened by the light of a deeper faith by virtue of baptism, the neophytes were at last able to understand these mysteries better, having celebrated their rites.

Especially with neophytes of Greek origin, Cyril made use of the faculty of sight which they found congenial. It was the passage from the rite to the mystery that made the most of the psychological effect of amazement, as well as the experience of Easter night.

Here is a text that explains the mystery of baptism: "You descended three times into the water, and ascended again, suggesting by a symbol the three days burial of Christ, imitating Our Savior who spent three days and three nights in the heart of the earth (cf. Mt 12:40). Celebrating the first emersion in water you recall the first day passed by Christ in the sepulcher; with the first immersion you confessed the first night passed in the sepulcher: for as he who is in the night no longer sees, but he who is in the day remains in the light, so in the descent, as in the night, you saw nothing, but in ascending again you were as in the day. And at the self-same moment you were both dying and being born; and that water of salvation was at once your grave and your mother.... For you... the time to die goes hand in hand with the time to be born: one and the same time effected both of these events" (cf. *Second Mystagogical Catechesis,* n. 4).

The mystery to be understood is God's plan, which is brought about through Christ's saving actions in the Church.

In turn, the mystagogical dimension is accompanied by the dimension of symbols which express the spiritual experience they "explode." Thus, Cyril's catechesis, on the basis of the three elements described — doctrinal, moral, and lastly, mystagogical — proves to be a global catechesis in the Spirit.

The mystagogical dimension brings about the synthesis of the two former dimensions, orienting them to the sacramental celebration in which the salvation of the whole human person takes place.

In short, this is an integral catechesis which — involving body, soul, and spirit — remains emblematic for the catechetical formation of Christians today.

St. Basil

Life and Writings[1]

Let us remember one of the great Fathers of the Church, St. Basil, described by Byzantine liturgical texts as "a luminary of the Church."

He was an important bishop in the fourth century to whom the entire Church of the East, and likewise the Church of the West, looks with admiration because of the holiness of his life, the excellence of his teaching, and the harmonious synthesis of his speculative and practical gifts.

He was born about A.D. 330 into a family of saints, "a true domestic Church," immersed in an atmosphere of deep faith. He studied with the best teachers in Athens and Constantinople.

Unsatisfied with his worldly success and realizing that he had frivolously wasted much time on vanities, he himself confessed: "One day, like a man roused from deep sleep, I turned my eyes to the marvelous light of the truth of the Gospel..., and I wept many tears over my miserable life" (cf. *Letter* 223: *PG* 32, 824a).

Attracted by Christ, Basil began to look and listen to him alone (cf. *Moralia,* 80, 1: *PG* 31, 860bc). He devoted himself with determination to the monastic life through prayer, meditation on the Sacred

[1] Pope Benedict XVI, General Audience, July 4, 2007.

Francisco de Herrera il Vecchio, *St. Basil Dictating His Rule*, Paris, Louvre museum

Scriptures, and the writings of the Fathers of the Church, and to the practice of charity (cf. *Letters* 2, 22), also following the example of his sister, St. Macrina, who was already living the ascetic life of a nun. He was then ordained a priest and finally, in the year 370, Bishop of Caesarea in Cappadocia in present-day Turkey.

Through his preaching and writings, he carried out immensely busy pastoral, theological, and literary activities.

With a wise balance, he was able to combine service to souls with dedication to prayer and meditation in solitude. Availing himself of his personal experience, he encouraged the foundation of numerous "fraternities," in other words, communities of Christians consecrated to God, which he visited frequently (cf. Gregory of Nazianzus, *Oratio* 43, 29, *in laudem Basilii: PG* 36, 536b).

He urged them with his words and his writings, many of which have come down to us (cf. *Regulae Brevius Tractatae*, Proemio: *PG* 31, 1080ab), to live and to advance in perfection.

Various legislators of ancient monasticism drew on his works, including St. Benedict, who considered Basil his teacher (cf. *Rule* 73, 5).

Indeed, Basil created a very special monasticism: it was not closed to the community of the local Church but instead was open to it. His monks belonged to the particular Church; they were her life-giving nucleus and, going before the other faithful in the following of Christ and not only in faith, showed a strong attachment to him — love for him — especially through charitable acts. These monks, who ran schools and hospitals, were at the service of the poor and thus demonstrated the integrity of Christian life.

In speaking of monasticism, the Servant of God John Paul II wrote: "For this reason many people think that the essential structure of the life of the Church, monasticism, was established, for all time, mainly by St. Basil; or that, at least, it was not defined in its more specific nature without his decisive contribution" (Apostolic Letter *Patres Ecclesiae*, n. 2, January 1980; *L'Osservatore Romano* English edition, February 25, p. 6).

As the bishop and pastor of his vast diocese, Basil was constantly concerned with the difficult material conditions in which his faithful lived; he firmly denounced the evils; he did all he could on behalf of the poorest and most marginalized people; he also intervened with rulers to alleviate the sufferings of the population, especially in times of disaster; he watched over the Church's freedom, opposing even the powerful in order to defend the right to profess the true faith (cf. Gregory of Nazianzus, *Oratio* 43, 48–51 *in laudem Basilii: PG* 36, 557c–561c).

Basil bore an effective witness to God, who is love and charity, by building for the needy various institutions (cf. Basil, *Letter* 94: *PG* 32, 488bc), virtually a "city" of mercy, called *"Basiliade"* after him (cf. Sozomeno, *Historia Eccl.* 6, 34: *PG* 67, 1397a). This was the origin of the modern hospital structures where the sick are admitted for treatment.

Aware that "the liturgy is the summit toward which the activity of the Church is directed," and "also the fount from which all her power flows" (*Sacrosanctum Concilium*, n. 10), and in spite of his constant concern to do charitable acts which is the hallmark of faith, Basil was also a wise "liturgical reformer" (cf. Gregory Nazianzus, *Oratio* 43, 34 *in laudem Basilii: PG* 36, 541c).

Indeed, he has bequeathed to us a great Eucharistic Prayer (or *anaphora*) which takes its name from him and has given a fundamental order to prayer and psalmody; because of the impulse he gave to the Psalms, the people loved and were familiar with them and even went to pray them during the night (cf. Basil, *In Psalmum* 1, 1–2: *PG* 29, 212a–213c). And we thus see how liturgy, worship, prayer with the Church and charity go hand in hand and condition one another.

With zeal and courage Basil opposed the heretics who denied that Jesus Christ was God like the Father (cf. Basil, *Letter* 9, 3: *PG* 32, 272a; *Letter* 52, 1–3: *PG* 32, 392b–396a; *Adv. Eunomium* 1, 20: *PG* 29, 556c). Likewise, against those who would not accept the divinity of the Holy Spirit, he maintained that the Spirit is also God and "must be equated and glorified with the Father and with the Son" (cf. *De Spiritu Sancto:*

SC 17ff., 348). For this reason Basil was one of the great Fathers who formulated the doctrine on the Trinity; the one God, precisely because he is love, is a God in three Persons who form the most profound unity that exists: divine unity.

In his love for Christ and for his Gospel, the great Cappadocian also strove to mend divisions within the Church (cf. *Letters,* 70, 243), doing his utmost to bring all to convert to Christ and to his word (cf. *De Iudicio* 4: *PG* 31, 660b–661a), a unifying force which all believers were bound to obey (cf. *De Iudicio* 1–3: *PG* 31, 653a–656c).

To conclude, Basil spent himself without reserve in faithful service to the Church and in the multiform exercise of the episcopal ministry. In accordance with the program that he himself drafted, he became an "apostle and minister of Christ, steward of God's mysteries, herald of the Kingdom, a model and rule of piety, an eye of the Body of the Church, a pastor of Christ's sheep, a loving doctor, father, and nurse, a cooperator of God, a farmer of God, a builder of God's temple" (cf. *Moralia* 80, 11–20: *PG* 31, 864b–868b).

This is the program which the holy bishop consigns to preachers of the Word — in the past as in the present — a program which he himself was generously committed to putting into practice. In A.D. 379, Basil, who was not yet fifty, returned to God "in the hope of eternal life, through Jesus Christ Our Lord" (*De Baptismo,* 1, 2, 9).

He was a man who truly lived with his gaze fixed on Christ. He was a man of love for his neighbor. Full of the hope and joy of faith, Basil shows us how to be true Christians.

Teachings[2]

Now, I would like to resume my catechesis on the life and writings of St. Basil, a bishop in present-day Turkey, in Asia Minor, in the fourth

[2] Pope Benedict XVI, General Audience, August 1, 2007.

Basil the Great, Sergiev Posad, Rome, Museo Storico Artistico Statale

century A.D. The life and works of this great saint are full of ideas for reflection and teachings that are also relevant for us today.

First of all is the reference to *God's mystery*, which is still the most meaningful and vital reference for human beings. The Father is "the principal of all things and the cause of being of all that exists, the root of the living" (*Hom.* 15, 2 *de fide: PG* 31, 465c); above all, he is "the Father of Our Lord Jesus Christ" (*Anaphora Sancti Basilii*). Ascending to God through his creatures, we "become aware of his goodness and wisdom" (Basil, *Adversus Eunomium* 1, 14: *PG* 29, 544b).

The Son is the "image of the Father's goodness and seal in the same form" (Cf. Basil, *In Psalmum* 48, 8; *PG* 29, 452ab; cf. also *De Baptismo* 1, 2: *SC* 357, 158). With his obedience and his Passion, the Incarnate Word carried out his mission as Redeemer of man (cf. Basil, *In Psalmum* 48, 8; *PG* 29, 452ab; cf. also *De Baptismo* 1, 2: *SC* 357, 158).

Lastly, he spoke fully of the Holy Spirit, to whom he dedicated a whole book. He reveals to us that the Spirit enlivens the Church, fills her with his gifts and sanctifies her.

The resplendent light of the divine mystery is reflected in man, the image of God, and exalts his dignity. Looking at Christ, one fully understands human dignity.

Basil exclaims: "[Man], be mindful of your greatness, remembering the price paid for you: look at the price of your redemption and comprehend your dignity!"(*In Psalmum* 48, 8: *PG* 29, 452b).

Christians in particular, conforming their lives to the Gospel, recognize that all people are brothers and sisters; that life is a stewardship of the goods received from God, which is why each one is responsible for the other, and whoever is rich must be as it were an "executor of the orders of God the Benefactor" (*Hom* 6 *de Avaritia: PG* 32, 1181–1196). We must all help one another and cooperate as members of one body (*Ep* 203, 3).

And on this point, he used courageous, strong words in his homilies. Indeed, anyone who desires to love his neighbor as himself, in

Pierre Hubert Suvleyras, *The Mass of St. Basil*, Paris, Louvre museum

accordance with God's commandment, "must possess no more than his neighbor" (*Hom. in Divites: PG* 31, 281b).

In times of famine and disaster, the holy bishop exhorted the faithful with passionate words "not to be more cruel than beasts ... by taking over what people possess in common or by grabbing what belongs to all" (*Hom. Tempore Famis: PG* 31, 325a).

Basil's profound thought stands out in this evocative sentence: "All the destitute look to our hands just as we look to those of God when we are in need."

Therefore, Gregory of Nazianzus's praise after Basil's death was well deserved. He said: "Basil convinces us that since we are human beings, we must neither despise men nor offend Christ, the common Head of all, with our inhuman behavior toward people; rather, we ourselves must benefit by learning from the misfortunes of others and must lend God our compassion, for we are in need of mercy" (Gregory Nazianzus, *Orationes* 43, 63; *PG* 36, 580b).

These words are very timely. We see that St. Basil is truly one of the Fathers of the Church's social doctrine.

Furthermore, Basil reminds us that to keep alive our love for God and for men, *we need the Eucharist,* the appropriate food for the baptized, which can nourish the new energies that derive from baptism (cf. *De Baptismo* 1, 3: *SC* 357, 192).

It is a cause of immense joy to be able to take part in the Eucharist (cf. *Moralia* 21, 3: *PG* 31, 741a), instituted "to preserve unceasingly the memory of the One who died and rose for us" (*Moralia* 80, 22: *PG* 31, 869b).

The Eucharist, an immense gift of God, preserves in each one of us the memory of the baptismal seal and makes it possible to live the grace of baptism to the full and in fidelity.

Liturgy of St. Basil, fresco, Ohrid (Macedonia), Church of St. Sophia

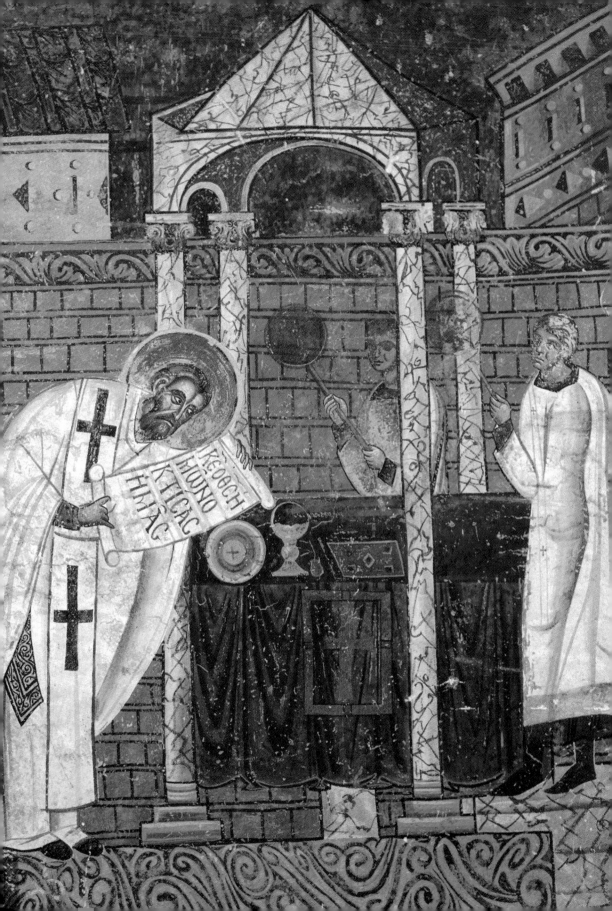

For this reason, the holy bishop recommended frequent, even daily, Communion: "Communicating even daily, receiving the Holy Body and Blood of Christ, is good and useful; for he said clearly: 'He who eats my flesh and drinks my blood has eternal life' (Jn 6:54). So who would doubt that communicating continuously with life was living in fullness?" (*Ep.* 93: *PG* 32, 484b).

The Eucharist, in a word, is necessary for us if we are to welcome within us true life, eternal life (Cf. *Moralia* 21, 1: *PG* 31, 737c).

Finally, Basil was of course also concerned with that chosen portion of the People of God, *the youth,* society's future. He addressed a *Discourse* to them on how to benefit from the pagan culture of that time.

He recognized with great balance and openness that examples of virtue can be found in classical Greek and Latin literature. Such examples of upright living can be helpful to young Christians in search of the truth and the correct way of living (cf. *Ad Adolescentes* 3).

Therefore, one must take from the texts by classical authors what is suitable and conforms with the truth: thus, with a critical and open approach — it is a question of true and proper "discernment" — young people grow in freedom.

With the famous image of bees that gather from flowers only what they need to make honey, Basil recommends: "Just as bees can take nectar from flowers, unlike other animals which limit themselves to enjoying their scent and color, so also from these writings… one can draw some benefit for the spirit. We must use these books, following in all things the example of bees. They do not visit every flower without distinction, nor seek to remove all the nectar from the flowers on which they alight, but only draw from them what they need to make honey, and leave the rest. And if we are wise, we will take from those writings what is appropriate for us, and conform to the truth, ignoring the rest" (*Ad Adolescentes* 4).

Basil recommended above all that young people grow in virtue, in the right way of living: "While the other goods… pass from one to the

other as in playing dice, virtue alone is an inalienable good and endures throughout life and after death" (*Ad Adolescentes* 5).

Dear brothers and sisters, I think one can say that this Father from long ago also speaks to us and tells us important things.

In the first place, attentive, critical, and creative participation in today's culture.

Then, social responsibility: this is an age in which, in a globalized world, even people who are physically distant are really our neighbors; therefore, friendship with Christ, the God with the human face.

And, lastly, knowledge and recognition of God the Creator, the Father of us all; only if we are open to this God, the common Father, can we build a more just and fraternal world.

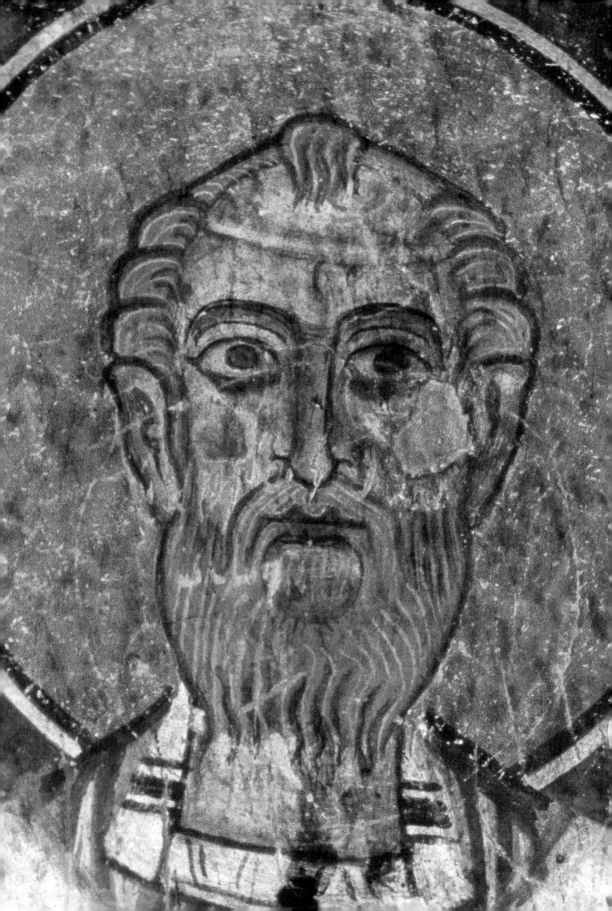

St. Gregory Nazianzus

Life and Writings[1]

I talked about St. Basil, a Father of the Church and a great teacher of the faith. Now, I would like to speak of his friend, Gregory Nazianzus; like Basil, he too was a native of Cappadocia. As a distinguished theologian, orator and champion of the Christian faith in the fourth century, he was famous for his eloquence, and as a poet, he also had a refined and sensitive soul.

Gregory was born into a noble family in about A.D. 330, and his mother consecrated him to God at birth. After his education at home, he attended the most famous schools of his time: he first went to Caesarea in Cappadocia, where he made friends with Basil, the future Bishop of that city, and went on to stay in other capitals of the ancient world, such as Alexandria, Egypt, and in particular Athens, where once again he met Basil (cf. *Orationes* 43: 14–24; *SC* 384: 146–180).

Remembering this friendship, Gregory was later to write: "Then not only did I feel full of veneration for my great Basil because of the seriousness of his morals and the maturity and wisdom of his speeches, but he induced others who did not yet know him to be like him.... The same

[1] Pope Benedict XVI, General Audience, August 8, 2007.

St. Gregory of Nazianzus, fresco, Eski Gümüs Monastery, Cappadocia (Turkey)

eagerness for knowledge motivated us.... This was our competition: not who was first but who allowed the other to be first. It seemed as if we had one soul in two bodies" (*Orationes* 43: 16, 20; SC 384: 154–156, 164).

These words more or less paint the self-portrait of this noble soul. Yet, one can also imagine how this man, who was powerfully cast beyond earthly values, must have suffered deeply for the things of this world.

On his return home, Gregory received baptism and developed an inclination for monastic life. Solitude as well as philosophical and spiritual meditation fascinated him.

He himself wrote: "Nothing seems to me greater than this: to silence one's senses, to emerge from the flesh of the world, to withdraw into oneself, no longer to be concerned with human things other than what is strictly necessary; to converse with oneself and with God, to lead a life that transcends the visible; to bear in one's soul divine images, ever pure, not mingled with earthly or erroneous forms; truly to be a perfect mirror of God and of divine things, and to become so more and more, taking light from light...; to enjoy, in the present hope, the future good, and to converse with angels; to have already left the earth even while continuing to dwell on it, borne aloft by the spirit" (*Orationes* 2: 7; *SC* 247: 96).

As he confides in his autobiography (cf. *Carmina [Historica]* 2: 1, 11, *De Vita Sua* 340–349; *PG* 37: 1053), he received priestly ordination with a certain reluctance for he knew that he would later have to be a bishop, to look after others and their affairs — hence, could no longer be absorbed in pure meditation.

However, he subsequently accepted this vocation and took on the pastoral ministry in full obedience, accepting, as often happened to him in his life, to be carried by Providence where he did not wish to go (cf. Jn 21: 18).

The Vision of Ezekiel, miniature from *Homilies of Gregory of Nazianzus*, Paris, National Library of France

In 371, his friend Basil, Bishop of Caesarea, against Gregory's own wishes, desired to ordain him Bishop of Sasima, a strategically important locality in Cappadocia. Because of various problems, however, he never took possession of it and instead stayed on in the city of Nazianzus.

In about 379, Gregory was called to Constantinople, the capital, to head the small Catholic community faithful to the Council of Nicaea and to belief in the Trinity. The majority adhered instead to Arianism, which was "politically correct" and viewed by emperors as politically useful.

Thus, he found himself in a condition of minority, surrounded by hostility. He delivered five *Theological Orations* (*Orationes* 27–31; *SC* 250: 70–343) in the little Church of the Anastasis precisely in order to defend the Trinitarian faith and to make it intelligible.

These discourses became famous because of the soundness of his doctrine and his ability to reason, which truly made clear that this was the divine logic. And the splendor of their form also makes them fascinating today.

It was because of these orations that Gregory acquired the nickname "The Theologian."

This is what he is called in the Orthodox Church, "The Theologian." And this is because to his way of thinking theology was not merely human reflection or, even less, only a fruit of complicated speculation, but rather sprang from a life of prayer and holiness, from a persevering dialogue with God. And in this very way he causes the reality of God, the mystery of the Trinity, to appear to our reason.

In the silence of contemplation, interspersed with wonder at the marvels of the mystery revealed, his soul was engrossed in beauty and divine glory.

While Gregory was taking part in the Second Ecumenical Council in 381, he was elected Bishop of Constantinople and presided over the Council; but he was immediately challenged by strong opposition, to the point that the situation became untenable. These hostilities must have been unbearable to such a sensitive soul.

What Gregory had previously lamented with heartfelt words was repeated: "We have divided Christ, we who so loved God and Christ! We have lied to one another because of the Truth, we have harbored sentiments of hatred because of Love, we are separated from one another" (*Orationes* 6: 3; *SC* 405: 128). Thus, in a tense atmosphere, the time came for him to resign.

In the packed cathedral, Gregory delivered a farewell discourse of great effectiveness and dignity (cf. *Orationes* 42; *SC* 384: 48–114). He ended his heartrending speech with these words: "Farewell, great city, beloved by Christ. . . . My children, I beg you, jealously guard the deposit [of faith] that has been entrusted to you (cf. 1 Tim 6:20), remember my suffering (cf. Col 4:18). May the grace of Our Lord Jesus Christ be with you all" (cf. *Orationes* 42: 27; *SC* 384: 112–114).

Gregory returned to Nazianzus and for about two years devoted himself to the pastoral care of this Christian community. He then withdrew definitively to solitude in nearby Arianzo, his birthplace, and dedicated himself to studies and the ascetic life.

It was in this period that he wrote the majority of his poetic works and especially his autobiography, the *De Vita Sua,* a reinterpretation in verse of his own human and spiritual journey, an exemplary journey of a suffering Christian, of a man of profound interiority in a world full of conflicts.

He is a man who makes us aware of God's primacy; hence, he also speaks to us, to this world of ours: without God, man loses his grandeur; without God, there is no true humanism.

Consequently, let us too listen to this voice and seek to know God's Face.

In one of his poems he wrote, addressing himself to God, "May you be benevolent, You, the hereafter of all things" (*Carmina [Dogmatica]* 1: 1, 29; *PG* 37: 508).

And in 390, God welcomed into his arms this faithful servant who had defended him in his writings with keen intelligence and had praised him in his poetry with such great love.

Teachings[2]

Reflecting on the mission God had entrusted to him, St. Gregory Nazianzus concluded: "I was created to ascend even to God with my actions" (*Orationes* 14, 6 *De Pauperum Amore: PG* 35, 865).

In fact, he placed his talents as a writer and orator at the service of God and of the Church. He wrote numerous discourses, various homilies and panegyrics, a great many letters and poetic works (almost 18,000 verses!) — a truly prodigious output.

He realized that this was the mission that God had entrusted to him: "As a servant of the Word, I adhere to the ministry of the Word; may I never agree to neglect this good. I appreciate this vocation and am thankful for it; I derive more joy from it than from all other things put together" (*Orationes* 6, 5: *SC* 405, 134; cf. also *Orationes* 4, 10).

Nazianzus was a mild man and always sought in his life to bring peace to the Church of his time, torn apart by discord and heresy. He strove with Gospel daring to overcome his own timidity in order to proclaim the truth of the faith.

He felt deeply the yearning to draw close to God, to be united with him. He expressed it in one of his poems in which he writes: "Among the great billows of the sea of life, here and there whipped up by wild winds... one thing alone is dear to me, my only treasure, comfort, and oblivion in my struggle, the light of the Blessed Trinity" (*Carmina [Historica]* 2, 1, 15: *PG* 37, 1250ff). Thus, Gregory made the light of the Trinity shine forth, defending the faith proclaimed at the Council of Nicaea: one God in three persons, equal and distinct — Father, Son, and Holy Spirit — "a triple light gathered into one splendor" (*Hymn for Vespers, Carmina [Historica]* 2, 1, 32: *PG* 37, 512).

Therefore, Gregory says further, in line with St. Paul (1 Cor 8:6): "For us there is one God, the Father, from whom is all; and one Lord,

[2] Pope Benedict XVI, General Audience, August 22, 2007.

Pieter Paul Rubens, *St. Gregory and Saints*, Chantilly, Musée Condé

Jesus Christ, through whom is all; and one Holy Spirit, in whom is all" (*Orationes* 39, 12: *SC* 358, 172).

Gregory gave great prominence to Christ's full humanity: to redeem man in the totality of his body, soul, and spirit, Christ assumed all the elements of human nature, otherwise man would not have been saved.

Disputing the heresy of Apollinaris, who held that Jesus Christ had not assumed a rational mind, Gregory tackled the problem in the light of the mystery of salvation: "What has not been assumed has not been healed" (*Ep.* 101, 32: *SC* 208, 50), and if Christ had not been "endowed with a rational mind, how could he have been a man?" (*Ep.* 101, 34: *SC* 208, 50). It was precisely our mind and our reason that needed and needs the relationship, the encounter with God in Christ.

Having become a man, Christ gave us the possibility of becoming, in turn, like him. Nazianzus exhorted people: "Let us seek to be like Christ, because Christ also became like us: to become gods through him since he himself, through us, became a man. He took the worst upon himself to make us a gift of the best" (*Orationes* 1, 5: *SC* 247, 78).

Mary, who gave Christ his human nature, is the true Mother of God (*Theotokos:* cf. *Ep.* 101, 16: *SC* 208, 42), and with a view to her most exalted mission was "purified in advance" (*Orationes* 38, 13: *SC* 358, 132, almost as a distant prelude to the Dogma of the Immaculate Conception). Mary is proposed to Christians, and especially to virgins, as a model and their help to call upon in times of need (cf. *Orationes*, 24, 11: *SC* 282, 60–64).

Gregory reminds us that as human persons, we must show solidarity to one another. He writes: "'We are all one in the Lord' (cf. Rom 12:5), rich and poor, slaves and free, healthy and sick alike; and one is the head from which all derive: Jesus Christ. And as with the members of one body, each is concerned with the other, and all with all."

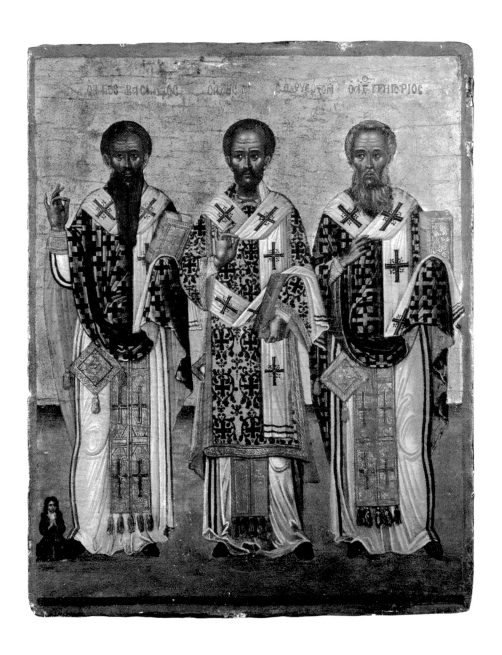

Sts. Basil, Chrysostom, and Gregory of Nazianzus, Melbourne (Australia), National Gallery of Victoria

He then concludes, referring to the sick and to people in difficulty: "This is the one salvation for our flesh and our soul: showing them charity" (*Orationes* 14, 8 *De Pauperum Amore: PG* 35, 868ab).

Gregory emphasizes that man must imitate God's goodness and love. He therefore recommends: "If you are healthy and rich, alleviate the need of whoever is sick and poor; if you have not fallen, go to the aid of whoever has fallen and lives in suffering; if you are glad, comfort whoever is sad; if you are fortunate, help whoever is smitten with misfortune. Give God proof of your gratitude, for you are one who can benefit and not one who needs to be benefited.... Be rich not only in possessions but also in piety; not only in gold but in virtue, or rather, in virtue alone. Outdo your neighbor's reputation by showing yourself to be kinder than all; make yourself God for the unfortunate, imitating God's mercy" (*Orationes* 14, 26 *De Pauperum Amore: PG* 35, 892bc).

Gregory teaches us first and foremost the importance and necessity of prayer. He says: "It is necessary to remember God more often that one breathes" (*Orationes* 27, 4: *PG* 250, 78), because prayer is the encounter of God's thirst with our thirst. God is thirsting for us to thirst for him (cf. *Orationes* 40, 27: *SC* 358, 260).

In prayer, we must turn our hearts to God, to consign ourselves to him as an offering to be purified and transformed. In prayer, we see all things in the light of Christ, we let our masks fall and immerse ourselves in the truth and in listening to God, feeding the fire of love.

In a poem which is at the same time a meditation on the purpose of life and an implicit invocation to God, Gregory writes: "You have a task, my soul, a great task if you so desire. Scrutinize yourself seriously — your being, your destiny; where you come from and where you must rest; seek to know whether it is life that you are living or if it is something more. You have a task, my soul, so purify your life: Please consider God and his mysteries, investigate what existed before this universe and what it is for you, where you come from and what your

destiny will be. This is your task, my soul; therefore, purify your life" (*Carmina [Historica]* 2, 1, 78: *PG 37*, 1425–1426).

The holy bishop continuously asked Christ for help, to be raised and set on his way: "I have been let down, O my Christ, by my excessive presumption: from the heights, I have fallen very low. But lift me now again so that I may see that I have deceived myself; if again I trust too much in myself, I shall fall immediately and the fall will be fatal" (*Carmina [Historica]* 2, 1, 67: *PG 37*, 1408).

So it was that Gregory felt the need to draw close to God in order to overcome his own weariness. He experienced the impetus of the soul, the vivacity of a sensitive spirit, and the instability of transient happiness.

For him, in the drama of a life burdened by the knowledge of his own weakness and wretchedness, the experience of God's love always gained the upper hand.

You have a task, soul, St. Gregory also says to us, the task of finding the true light, of finding the true nobility of your life. And your life is encountering God, who thirsts for our thirst.

ἰάκωβοσμοναχός :-

CHAPTER FOURTEEN

St. Gregory of Nyssa

Life and Writings[1]

In previous chapters, I spoke of two great fourth-century Doctors of the Church, Basil and Gregory Nazianzus, a bishop in Cappadocia, in present-day Turkey. Now, we are adding a third, St. Gregory of Nyssa, Basil's brother, who showed himself to be a man disposed to meditation with a great capacity for reflection and a lively intelligence open to the culture of his time. He has thus proved to be an original and profound thinker in the history of Christianity.

He was born in about A.D. 335. His Christian education was supervised with special care by his brother Basil — whom he called "father and teacher" (*Ep.* 13, 4: *SC* 363, 198) — and by his sister Macrina. He completed his studies, appreciating in particular philosophy and rhetoric.

Initially, he devoted himself to teaching and was married. Later, like his brother and sister, he too dedicated himself entirely to the ascetic life.

He was subsequently elected Bishop of Nyssa and showed himself to be a zealous pastor, thereby earning the community's esteem.

[1] Pope Benedict XVI, General Audience, August 29, 2007.

Gregory of Nyssa and John Chrysostom with Two Monks, miniature from *Homilies to the Virgin*, fol. 1v, Paris, National Library of France

125

When he was accused of embezzlement by heretical adversaries, he was obliged for a brief period to abandon his episcopal see but later returned to it triumphant (cf. *Ep.* 6: *SC* 363, 164–170) and continued to be involved in the fight to defend the true faith.

Especially after Basil's death, by more or less gathering his spiritual legacy, Gregory cooperated in the triumph of orthodoxy. He took part in various synods; he attempted to settle disputes between Churches; he had an active part in the reorganization of the Church and, as a "pillar of orthodoxy," played a leading role at the Council of Constantinople in 381, which defined the divinity of the Holy Spirit.

Various difficult official tasks were entrusted to him by the Emperor Theodosius, he delivered important homilies and funeral discourses, and he devoted himself to writing various theological works. In addition, in 394, he took part in another synod, held in Constantinople. The date of his death is unknown.

Gregory expressed clearly the purpose of his studies, the supreme goal to which all his work as a theologian was directed: not to engage his life in vain things but to find the light that would enable him to discern what is truly worthwhile (cf. *In Ecclesiasten Hom.* 1: *SC* 416, 106–146).

He found this supreme good in Christianity, thanks to which "the imitation of the divine nature" is possible (*De Professione Christiana*: *PG* 46, 244c).

With his acute intelligence and vast philosophical and theological knowledge, he defended the Christian faith against heretics who denied the divinity of the Son and of the Holy Spirit (such as Eunomius and the Macedonians) or compromised the perfect humanity of Christ (such as Apollinaris).

He commented on Sacred Scripture, reflecting on the creation of man. This was one of his central topics: creation. He saw in the creature the reflection of the Creator and found here the way that leads to God.

But he also wrote an important book on the life of Moses, whom he presents as a man journeying toward God: this climb to Mount Sinai

became for him an image of our ascent in human life toward true life, toward the encounter with God.

He also interpreted the Lord's Prayer (the Our Father) as well as the Beatitudes. In his "Great Catechetical Discourse" (*Oratio Catechetica Magna*) he developed theology's fundamental directions, not for an academic theology closed in on itself but in order to offer catechists a reference system to keep before them in their instructions, almost as a framework for a pedagogical interpretation of the faith.

Furthermore, Gregory is distinguished for his spiritual doctrine. None of his theology was academic reflection; rather, it was an expression of the spiritual life, of a life of faith lived. As a great "father of mysticism," he pointed out in various treatises — such as his *De Professione Christiana* and *De Perfectione Christiana* — the path Christians must take if they are to reach true life, perfection.

He exalted consecrated virginity (*De Virginitate*) and proposed the life of his sister Macrina, who was always a guide and example for him (cf. *Vita Macrinae*), as an outstanding model of it.

Gregory gave various discourses and homilies and wrote numerous letters. In commenting on man's creation, he highlighted the fact that God, "the best artist, forges our nature so as to make it suitable for the exercise of royalty. Through the superiority given by the soul and through the very make-up of the body, he arranges things in such a way that man is truly fit for regal power" (*De Hominis Opificio* 4: *PG* 44, 136b).

Yet, we see that man, caught in the net of sin, often abuses creation and does not exercise true kingship. For this reason, in fact, that is, to act with true responsibility for creatures, he must be penetrated by God and live in his light.

Indeed, man is a reflection of that original beauty which is God: "Everything God created was very good," the holy bishop wrote. And he added: "The story of creation (cf. Gen 1:31) witnesses to it. Man was also listed among those very good things, adorned with a beauty far

superior to all of the good things. What else, in fact, could be good, on par with one who was similar to pure and incorruptible beauty?... The reflection and image of eternal life, he was truly good; no, he was very good, with the radiant sign of life on his face" (*Homilia in Canticum* 12: *PG* 44, 1020c).

Man was honored by God and placed above every other creature: "The sky was not made in God's image, not the moon, not the sun, not the beauty of the stars, no other things which appear in creation. Only you *(human soul)* were made to be the image of nature that surpasses every intellect, likeness of incorruptible beauty, mark of true divinity, vessel of blessed life, image of true light — that when you look upon it you become what he is, because through the reflected ray coming from your purity you imitate he who shines within you. Nothing that exists can measure up to your greatness" (*Homilia in Canticum* 2: *PG* 44, 805d).

Let us meditate on this praise of the human being. Let us also see how man was degraded by sin. And let us try to return to that original greatness: only if God is present, does man attain his true greatness.

Man therefore recognizes in himself the reflection of the divine light: by purifying his heart he is once more, as he was in the beginning, a clear image of God, exemplary Beauty (cf. *Oratio Catechetica* 6: *SC* 453, 174).

Thus, by purifying himself, man can see God, as do the pure of heart (cf. Mt 5:8): "If, with a diligent and attentive standard of living, you wash away the bad things that have deposited upon your heart, the divine beauty will shine in you.... Contemplating yourself, you will see within you he who is the desire of your heart, and you will be blessed" (*De Beatitudinibus* 6: *PG* 44, 1272ab). We should therefore wash away the ugliness stored within our hearts and rediscover God's light within us.

Man's goal is therefore the contemplation of God. In him alone can he find his fulfillment.

To somehow anticipate this goal in this life, he must work ceaselessly toward a spiritual life, a life in dialogue with God. In other words —

and this is the most important lesson that St. Gregory of Nyssa has bequeathed to us — total human fulfillment consists in holiness, in a life lived in the encounter with God, which thus becomes luminous also to others and to the world.

Teachings[2]

I present to you certain aspects of the teachings of St. Gregory of Nyssa. First of all, Gregory of Nyssa had a very lofty concept of human dignity. Man's goal, the holy bishop said, is to liken himself to God, and he reaches this goal first of all through the love, knowledge and practice of the virtues, *"bright beams that shine from the divine nature"* (*De Beatitudinibus* 6: *PG* 44, 1272c) in a perpetual movement of adherence to the good like a corridor outstretched before oneself. In this regard, Gregory uses an effective image already present in Paul's *Letter to the Philippians*: *épekteinómenos* (3:13); that is, "I press on" toward what is greater, toward truth and love. This vivid expression portrays a profound reality: the perfection we desire to attain is not acquired once and for all; perfection means journeying on, it is continuous readiness to move ahead because we never attain a perfect likeness to God; we are always on our way. The history of every soul is that of a love which fills every time and at the same time is open to new horizons, for God continually stretches the soul's possibilities to make it capable of ever-greater goods. God himself, who has sown the seeds of good in us and from whom every initiative of holiness stems, "models the block..., and polishing and cleansing our spirit, forms Christ within us" (*In Psalmos* 2, 11: *PG* 44, 544b).

Gregory was anxious to explain: "In fact, this likeness to the Divine is not our work at all; it is not the achievement of any faculty of man; it is the great gift of God bestowed upon our nature at the very moment of our birth" (*De Virginitate* 12, 2: *SC* 119, 408–410). For the soul, therefore, "it is not a question of knowing something about God but of having God within" (*De Beatitudinibus* 6: *PG* 44, 1269c).

[2] Pope Benedict XVI, General Audience, September 5, 2007.

Moreover, as Gregory perceptively observes, "Divinity is purity, it is liberation from the passions and the removal of every evil: if all these things are in you, God is truly in you" (*De Beatitudinibus* 6: *PG* 44, 1272c).

When we have God in us, when man loves God, through that reciprocity which belongs to the law of love he wants what God himself wants (cf. *Homilia in Canticum* 9: *PG* 44, 956ac); hence, he cooperates with God in fashioning the divine image in himself, so that "our spiritual birth is the result of a free choice, and we are in a certain way our own parents, creating ourselves as we ourselves wish to be, and through our will forming ourselves in accordance with the model that we choose" (*Vita Moysis* 2, 3: *SC* 1ff., 108). To ascend to God, man must be purified: "The way that leads human nature to Heaven is none other than detachment from the evils of this world.... Becoming like God means becoming righteous, holy, and good.... If, therefore, according to Ecclesiastes (5:2), 'God is in Heaven,' and if, as the Prophet says, you 'have the Lord GOD [your] refuge' (Ps 73[72]:28), it necessarily follows that you must be where God is found, since you are united with him. Since he commanded you to call God 'Father' when you pray, he tells you definitely to be likened to your Heavenly Father and to lead a life worthy of God, as the Lord orders us more clearly elsewhere, saying, 'Be perfect as your heavenly Father is perfect' (Mt 5:48)" (*De Oratione Dominica* 2: *PG* 44, 1145ac).

In this journey of spiritual *ascesis* Christ is the Model and Teacher, he shows us the beautiful image of God (cf. *De Perfectione Christiana: PG* 46, 272a). Each of us, looking at him, finds ourself "the painter of our own life," who has the will to compose the work and the virtues as his colors (*De Perfectione Christiana: PG* 46, 272b). So, if man is deemed worthy of Christ's Name how should he behave? This is Gregory's answer: "[He must] always examine his own thoughts, his

Sts. Gregory of Nyssa, Basil and Gregory of Nazianzus, miniature from *Homilies of Gregory of Nazianzus*, Paris, National Library of France, fol. 71v

own words and his own actions in his innermost depths to see whether they are oriented to Christ or are drifting away from him" (*De Perfectione Christiana: PG* 46, 284c). And this point is important because of the value it gives to the word "Christian." A Christian is someone who bears Christ's Name, who must therefore also liken his life to Christ. We Christians assume a great responsibility with baptism.

But Christ, Gregory says, is also present in the poor, which is why they must never be offended: "Do not despise them, those who lie idle, as if for this reason they were worth nothing. Consider who they are and you will discover wherein lies their dignity: they represent the Person of the Savior. And this is how it is: for in his goodness the Lord gives them his own Person so that through it, those who are hard of heart and enemies of the poor may be moved to compassion" (*De Pauperibus Amandis: PG* 46, 460bc).

Gregory, as we said, speaks of rising: rising to God in prayer through purity of heart, but also rising to God through love of neighbor. Love is the ladder that leads to God. Consequently, Gregory of Nyssa strongly recommends to all his listeners: "Be generous with these brothers and sisters, victims of misfortune. Give to the hungry from what you deprive your own stomach" (*De Pauperibus Amandis: PG* 46, 457c).

Gregory recalls with great clarity that we all depend on God and therefore exclaims: "Do not think that everything belongs to you! There must also be a share for the poor, God's friends. In fact, the truth is that everything comes from God, the universal Father, and that we are brothers and sisters and belong to the same lineage" (*De Pauperibus Amandis: PG,* 465b).

The Christian should then examine himself, Gregory insists further: "But what use is it to fast and abstain from eating meat if with your wickedness all you do is to gnaw at your brother? What do you gain in God's eyes from not eating your own food if later, acting unfairly, you snatch from their hands the food of the poor?"

Let us end our catechesis on the three great Cappadocian Fathers by recalling that important aspect of Gregory of Nyssa's spiritual doctrine which is prayer. To progress on the journey to perfection and to welcome God within him, to bear the Spirit of God within him, the love of God, man must turn to God trustingly in prayer: "Through prayer we succeed in being with God. But anyone who is with God is far from the enemy. Prayer is a support and protection of charity, a brake on anger, an appeasement and the control of pride. Prayer is the custody of virginity, the protection of fidelity in marriage, the hope for those who are watching, an abundant harvest for farmers, certainty for sailors" (*De Oratione Dominica* 1: *PG* 44, 1124ab). The Christian always prays by drawing inspiration from the Lord's Prayer: "So if we want to pray for the Kingdom of God to come, we must ask him for this with the power of the Word: that I may be distanced from corruption, delivered from death, freed from the chains of error; that death may never reign over me, that the tyranny of evil may never have power over us, that the adversary may never dominate me nor make me his prisoner through sin but that your Kingdom may come to me so that the passions by which I am now ruled and governed may be distanced, or better still, blotted out" (*De Oratione Dominica* 3: *PG* 44, 1156d–1157a).

Having ended his earthly life, the Christian will thus be able to turn to God serenely. In speaking of this, St. Gregory remembered the death of his sister Macrina and wrote that she was praying this prayer to God while she lay dying: "You who on earth have the power to take away sins, 'forgive me, so that I may find refreshment' (cf. Ps 38:14), and so that I may be found without blemish in your sight at the time when I am emptied from my body (cf. Col 2:11), so that my spirit, holy, and immaculate (cf. Eph 5:27), may be accepted into your hands 'like incense before you' (Ps 141: [140]: 2)" (*Vita Macrinae* 24: *SC* 178, 224). This teaching of St. Gregory is always relevant: not only speaking of God, but carrying God within oneself. Let us do this by commitment to prayer and living in a spirit of love for all our brethren.

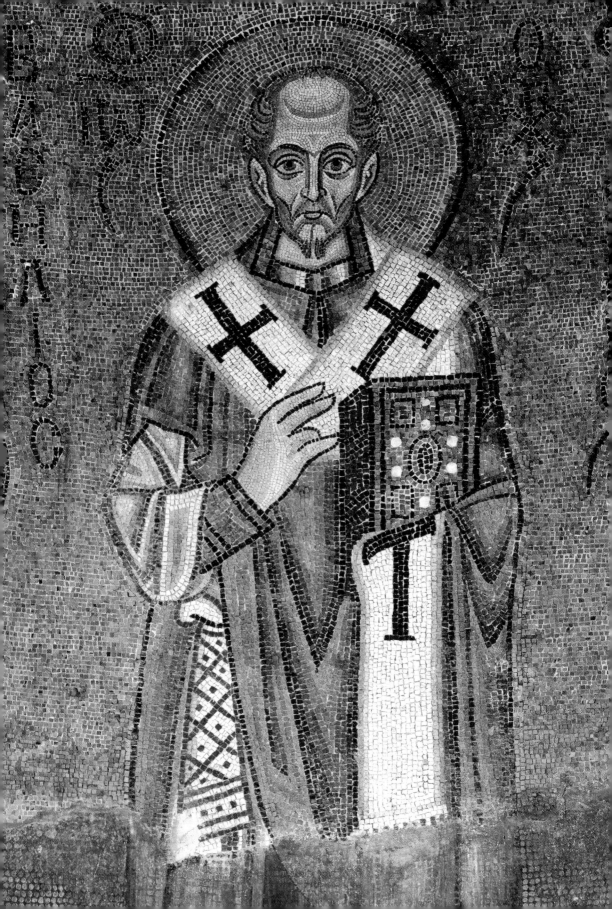

St. John Chrysostom

The Years in Antioch[1]

The year 2007 was the sixteenth centenary of St. John Chrysostom's death (407–2007). It can be said that John of Antioch, nicknamed "Chrysostom," that is, "golden-mouthed," because of his eloquence, is also still alive today because of his works. An anonymous copyist left in writing that "they cross the whole globe like flashes of lightning."

Chrysostom's writings also enable us, as they did the faithful of his time whom his frequent exiles deprived of his presence, to live with his books, despite his absence. This is what he himself suggested in a letter when he was in exile (*To Olympias,* Letter 8, 45).

He was born in about the year A.D. 349 in Antioch, Syria (today Antakya in Southern Turkey). He carried out his priestly ministry there for about eleven years, until 397, when, appointed Bishop of Constantinople, he exercised his episcopal ministry in the capital of the empire prior to his two exiles, which succeeded one close upon the other — in 403 and 407. Let us limit ourselves first to examining the years Chrysostom spent in Antioch.

[1] Pope Benedict XVI, General Audience, September 19, 2007.

St. John Chrysostom, mosaic, Kiev (Russia), Church of St. Sophia.

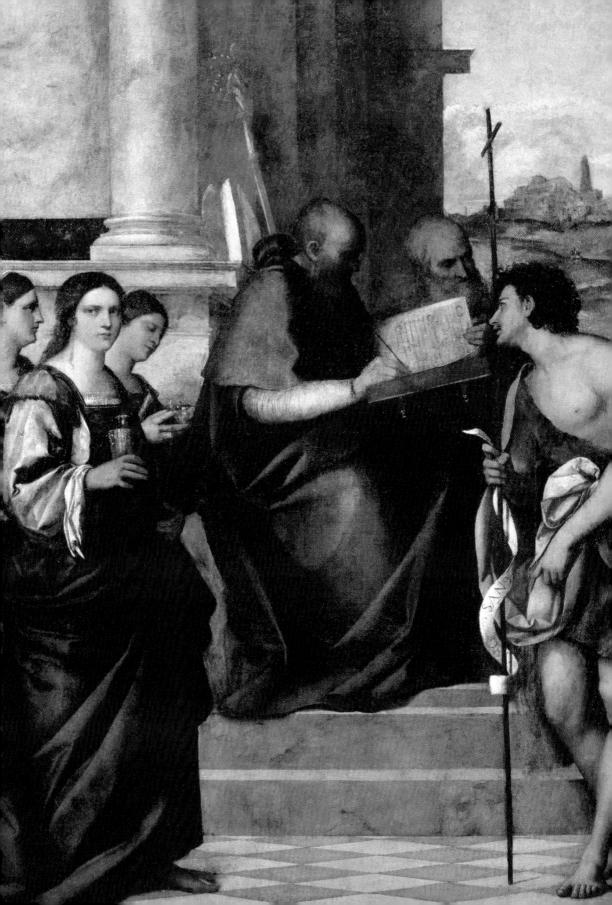

He lost his father at a tender age and lived with Anthusa, his mother, who instilled in him exquisite human sensitivity and a deep Christian faith.

After completing his elementary and advanced studies crowned by courses in philosophy and rhetoric, he had as his teacher, Libanius, a pagan and the most famous rhetorician of that time. At his school John became the greatest orator of late Greek antiquity.

He was baptized in 368 and trained for the ecclesiastical life by Bishop Meletius, who instituted him as lector in 371. This event marked Chrysostom's official entry into the ecclesiastical *cursus*. From 367 to 372, he attended the *Asceterius,* a sort of seminary in Antioch, together with a group of young men, some of whom later became bishops, under the guidance of the exegete Diodore of Tarsus, who initiated John into the literal and grammatical exegesis characteristic of Antiochean tradition.

He then withdrew for four years to the hermits on the neighboring Mount Silpius. He extended his retreat for a further two years, living alone in a cave under the guidance of an "old hermit." In that period, he dedicated himself unreservedly to meditating on "the laws of Christ," the Gospels and especially the Letters of Paul. Having fallen ill, he found it impossible to care for himself unaided, and therefore had to return to the Christian community in Antioch (cf. Palladius, *Dialogue on the Life of St. John Chrysostom,* 5).

The Lord, his biographer explains, intervened with the illness at the right moment to enable John to follow his true vocation. In fact, he himself was later to write that were he to choose between the troubles of Church government and the tranquility of monastic life, he would have preferred pastoral service a thousand times (cf. *On the Priesthood,* 6, 7): it was precisely to this that Chrysostom felt called.

It was here that he reached the crucial turning point in the story of his vocation: a full-time pastor of souls! Intimacy with the Word of

Sebastiano del Piombo, *St. John Chrysostom and Saints*, Venice (Italy), Church of San Giovanni Crisostomo

God, cultivated in his years at the hermitage, had developed in him an irresistible urge to preach the Gospel, to give to others what he himself had received in his years of meditation. The missionary ideal thus launched him into pastoral care, his heart on fire.

Between 378 and 379, he returned to the city. He was ordained a deacon in 381 and a priest in 386, and became a famous preacher in his city's churches. He preached homilies against the Arians, followed by homilies commemorating the Antiochean martyrs and other important liturgical celebrations: this was an important teaching of faith in Christ and also in the light of his saints.

The year 387 was John's "heroic year," that of the so-called "revolt of the statues." As a sign of protest against levied taxes, the people destroyed the emperor's statues. It was in those days of Lent and the fear of the emperor's impending reprisal that Chrysostom gave his twenty-two vibrant *Homilies on the Statues,* whose aim was to induce repentance and conversion. This was followed by a period of serene pastoral care (387–397).

Chrysostom is among the most prolific of the Fathers: seventeen treatises, more than seven hundred authentic homilies, commentaries on Matthew and on Paul (Letters to the Romans, Corinthians, Ephesians and Hebrews) and two hundred forty-one letters are extant. He was not a speculative theologian.

Nevertheless, he passed on the Church's tradition and reliable doctrine in an age of theological controversies, sparked above all by Arianism or, in other words, the denial of Christ's divinity. He is therefore a trustworthy witness of the dogmatic development achieved by the Church from the fourth to the fifth centuries.

His is a perfectly pastoral theology in which there is constant concern for consistency between thought expressed via words and existential experience. It is this in particular that forms the main theme of

Andrej Rublev, Daniil Cernyj, *St. John Chrysostom,* Moscow, Tret'jakov Gallery

the splendid catecheses with which he prepared catechumens to receive baptism.

On approaching death, he wrote that the value of the human being lies in "exact knowledge of true doctrine and in rectitude of life" (*Letter from Exile*). Both these things, knowledge of truth and rectitude of life, go hand in hand: knowledge has to be expressed in life. All his discourses aimed to develop in the faithful the use of intelligence, of true reason, in order to understand and to put into practice the moral and spiritual requirements of faith.

John Chrysostom was anxious to accompany his writings with the person's integral development in his physical, intellectual and religious dimensions. The various phases of his growth are compared to as many seas in an immense ocean: "The first of these seas is childhood" (*Homily* 81, 5 *on Matthew's Gospel*).

Indeed, "it is precisely at this early age that inclinations to vice or virtue are manifest." Thus, God's law must be impressed upon the soul from the outset "as on a wax tablet" (*Homily* 3, 1 *on John's Gospel*): This is indeed the most important age. We must bear in mind how fundamentally important it is that the great orientations which give man a proper outlook on life truly enter him in this first phase of life.

Chrysostom therefore recommended: "From the tenderest age, arm children with spiritual weapons and teach them to make the Sign of the Cross on their forehead with their hand" (*Homily* 12, 7 *on First Corinthians*).

Then come adolescence and youth: "Following childhood is the sea of adolescence, where violent winds blow..., for concupiscence... grows within us" (*Homily* 81, 5 *on Matthew's Gospel*).

Lastly comes engagement and marriage: "Youth is succeeded by the age of the mature person who assumes family commitments: this is the time to seek a wife" (*Homily* 81, 5 *on Matthew's Gospel*).

He recalls the aims of marriage, enriching them — referring to virtue and temperance — with a rich fabric of personal relationships.

Properly prepared spouses therefore bar the way to divorce: everything takes place with joy and children can be educated in virtue. Then when the first child is born, he is "like a bridge; the three become one flesh, because the child joins the two parts" (*Homily* 12, 5 *on the Letter to the Colossians*), and the three constitute "a family, a Church in miniature" (*Homily* 20, 6 *on the Letter to the Ephesians*).

Chrysostom's preaching usually took place during the liturgy, the "place" where the community is built with the Word and the Eucharist. The assembly gathered here expresses the one Church (*Homily* 8, 7 *on the Letter to the Romans*), the same word is addressed everywhere to all (*Homily* 24, 2 *on First Corinthians*), and Eucharistic Communion becomes an effective sign of unity (*Homily* 32, 7 *on Matthew's Gospel*).

His pastoral project was incorporated into the Church's life, in which the lay faithful assume the priestly, royal and prophetic office with baptism. To the lay faithful he said: "Baptism will also make you king, priest, and prophet" (*Homily* 3, 5 *on Second Corinthians*).

From this stems the fundamental duty of the mission, because each one is to some extent responsible for the salvation of others: "This is the principle of our social life... not to be solely concerned with ourselves!" (*Homily* 9, 2 *on Genesis*). This all takes place between two poles: the great Church and the "Church in miniature," the family, in a reciprocal relationship.

As you can see, dear brothers and sisters, Chrysostom's lesson on the authentically Christian presence of the lay faithful in the family and in society is still more timely than ever today. Let us pray to the Lord to make us docile to the teachings of this great Master of the faith.

The Years in Constantinople[2]

Let us continue our reflection on St. John Chrysostom. After the period he spent in Antioch, in 397 he was appointed Bishop of Constanti-

[2] Pope Benedict XVI, General Audience, September 26, 2007.

nople, the capital of the Roman Empire of the East. John planned the reform of his Church from the outset: the austerity of the episcopal residence had to be an example for all — clergy, widows, monks, courtiers and the rich. Unfortunately, many of those he criticized distanced themselves from him. Attentive to the poor, John was also called "the Almoner." Indeed, he was able as a careful administrator to establish highly appreciated charitable institutions. For some people, his initiatives in various fields made him a dangerous rival, but as a true pastor, he treated everyone in a warm, fatherly way. In particular, he always spoke kindly to women and showed special concern for marriage and the family. He would invite the faithful to take part in liturgical life, which he made splendid and attractive with brilliant creativity.

Despite his kind heart, his life was far from peaceful. He was the pastor of the capital of the empire, and often found himself involved in political affairs and intrigues because of his ongoing relations with the authorities and civil institutions. Then, within the Church, having removed six bishops in Asia in A.D. 401 who had been improperly appointed, he was accused of having overstepped the boundaries of his own jurisdiction and thus he easily became the target of accusations.

Another accusation against him concerned the presence of some Egyptian monks, excommunicated by Patriarch Theophilus of Alexandria, who had sought refuge in Constantinople. A heated argument then flared up on account of Chrysostom's criticism of the Empress Eudoxia and her courtiers who reacted by heaping slander and insults upon him.

Thus, they proceeded to his removal during the Synod organized by the same Patriarch Theophilus in 403, which led to his condemnation and his first, brief exile. After Chrysostom's return, the hostility he had instigated by his protests against the festivities in honor of the empress, which the bishop considered as sumptuous pagan celebrations,

St. John Chrysostom, fresco, Tsalendjika (Georgia), Church of the Holy Savior

and by his expulsion of the priests responsible for the baptisms during the Easter Vigil in 404, marked the beginning of the persecution of Chrysostom and his followers, the so-called "Johannites."

John then denounced the events in a letter to Innocent I, Bishop of Rome, but it was already too late. In 406, he was once again forced into exile, this time to Cucusus in Armenia. The Pope was convinced of his innocence but was powerless to help him.

A Council desired by Rome to establish peace between the two parts of the empire and among their Churches could not take place. The grueling journey from Cucusus to Pityus, a destination that he never reached, was meant to prevent the visits of the faithful and to break the resistance of the worn-out exile: his condemnation to exile was a true death sentence!

The numerous letters from his exile in which John expressed his pastoral concern in tones of participation and sorrow at the persecution of his followers are moving. His journey toward death stopped at Comana in Ponto. Here, John, who was dying, was carried into the Chapel of the Martyr St. Basiliscus, where he gave up his spirit to God and was buried, one martyr next to the other (Palladius, *Dialogue on the Life of St. John Chrysostom,* 119). It was September 14, 407, the Feast of the Triumph of the Holy Cross.

He was rehabilitated in 438 through Theodosius II. The holy bishop's relics, which had been placed in the Church of the Apostles in Constantinople, were later, in 1204, translated to the first Constantinian Basilica in Rome, and now rest in the chapel of the Choir of the Canons in St. Peter's Basilica.

Lucas Cranach il Vecchio, *St. John Chrysostom,* Aschaffenburg (Germany), Staatsgalerie im Schloss Johannisburg

On pages 146–147: Joseph Wencker, *St. John Chrysostom Preaches before the Empress Eudocia,* Le Puy-en-Velay (France), Musée Crozatier

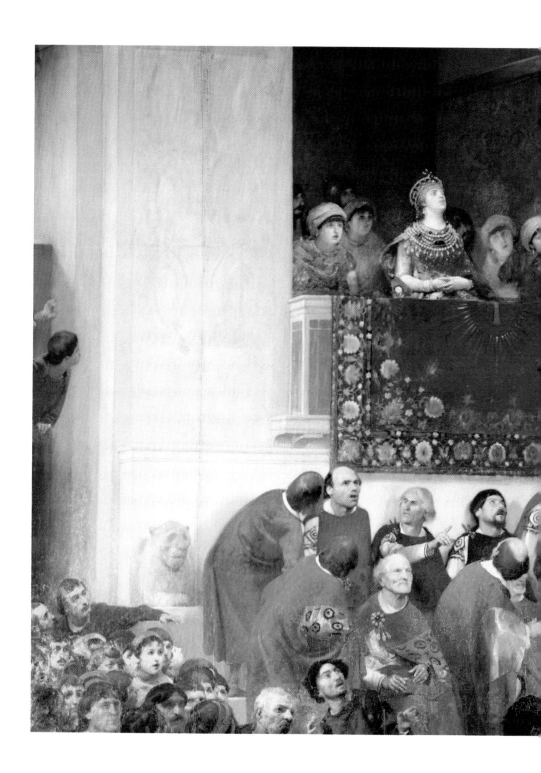

146

On August 24, 2004, Pope John Paul II gave a large part of the saint's relics to Patriarch Bartholomew I of Constantinople. The saint's liturgical Memorial is celebrated on September 13. Blessed John XXIII proclaimed him patron of the Second Vatican Council.

It is said of John Chrysostom that when he was seated upon the throne of the New Rome, that is, Constantinople, God caused him to be seen as a second Paul, a doctor of the universe. Indeed, there is in Chrysostom a substantial unity of thought and action, in Antioch as in Constantinople. It is only the role and situations that change.

In his commentary on Genesis, in meditating on God's eight acts in the sequence of six days, Chrysostom desired to restore the faithful from the creation to the Creator: "It is a great good," he said, "to know the creature from the Creator." He shows us the beauty of the creation and God's transparency in his creation, which thus becomes, as it were, a "ladder" to ascend to God in order to know him.

To this first step, however, is added a second: this God Creator is also the God of indulgence (*synkatabasis*). We are weak in "climbing," our eyes grow dim. Thus, God becomes an indulgent God who sends to fallen man, foreign man, a letter, Sacred Scripture, so that the creation and Scripture may complete each other.

We can decipher creation in the light of Scripture, the letter that God has given to us. God is called a "tender father," (*philostorgios*) (Palladius, *Dialogue on the Life of St. John Chrysostom,* 119), a healer of souls (*Homily on Genesis*, 40, 3), a mother (*Homily on Genesis*, 40, 3), and an affectionate friend (*On Providence* 8, 11–12). But in addition to this second step — first, the creation as a "ladder" to God, and then, the indulgence of God through a letter which he has given to us, Sacred Scripture — there is a third step.

God does not only give us a letter: ultimately, he himself comes down to us, he takes flesh, becomes truly "God-with-us," our brother until his death on a Cross. And to these three steps — God is visible in creation, God gives us a letter, God descends and becomes one of us —

Sts. Parasceve, Gregory the Theologian, John Chrysostom and Basil the Great,
Moscow, Tret'jakov Gallery

a fourth is added at the end. In the Christian's life and action, the vital and dynamic principle is the Holy Spirit (*Pneuma*) who transforms the realities of the world. God enters our very existence through the Holy Spirit and transforms us from within our hearts.

Against this background, in Constantinople itself, John proposed in his continuing *Commentary on the Acts of the Apostles* the model of the primitive Church (Acts 4:32–37) as a pattern for society, developing a social "utopia" (almost an "ideal city"). In fact, it was a question of giving the city a soul and a Christian face.

In other words, Chrysostom realized that it is not enough to give alms, to help the poor sporadically, but it is necessary to create a new structure, a new model of society; a model based on the outlook of the New Testament. It was this new society that was revealed in the newborn Church.

John Chrysostom thus truly became one of the great Fathers of the Church's social doctrine: the old idea of the Greek "polis" gave way to the new idea of a city inspired by Christian faith. With Paul (cf. 1 Cor 8:11), Chrysostom upheld the primacy of the individual Christian, of the person as such, even of the slave and the poor person. His project thus corrected the traditional Greek vision of the "polis," the city in which large sectors of the population had no access to the rights of citizenship while in the Christian city all are brothers and sisters with equal rights.

The primacy of the person is also a consequence of the fact that it is truly by starting with the person that the city is built, whereas in the Greek "polis" the homeland took precedence over the individual who was totally subordinated to the city as a whole. So it was that a society built on the Christian conscience came into being with Chrysostom. And he tells us that our "polis" [city] is another, "our commonwealth is in heaven" (Phil 3:20) and our homeland, even on this earth, makes us all equal, brothers and sisters, and binds us to solidarity.

At the end of his life, from his exile on the borders of Armenia, "the most remote place in the world," John, linking up with his first preaching in 386, took up the theme of the plan for humanity that God pursues, which was so dear to him: it is an "indescribable and incomprehensible" plan, but certainly guided lovingly by him (cf. *On Providence,* 2, 6).

Of this we are certain. Even if we are unable to unravel the details of our personal and collective history, we know that God's plan is always inspired by his love. Thus, despite his suffering, Chrysostom reaffirmed the discovery that God loves each one of us with an infinite love and therefore desires salvation for us all.

For his part, throughout his life the holy bishop cooperated generously in this salvation, never sparing himself. Indeed, he saw the ultimate end of his existence as that glory of God which — now dying — he left as his last testament: "Glory be to God for all things" (*Palladius, op.* cit., n. 11).

St. Cyril of Alexandria[1]

Continuing our journey following the traces left by the Fathers of the Church, we meet an important figure: St. Cyril of Alexandria. Linked to the Christological controversy which led to the Council of Ephesus in 431 and the last important representative of the Alexandrian tradition in the Greek Orient, Cyril was later defined as "the guardian of exactitude" — to be understood as guardian of the true faith — and even the "seal of the Fathers."

These ancient descriptions express clearly a characteristic feature of Cyril: the Bishop of Alexandria's constant reference to earlier ecclesiastical authors (including, in particular, Athanasius), for the purpose of showing the continuity with tradition of theology itself. He deliberately, explicitly inserted himself into the Church's tradition, which he recognized as guaranteeing continuity with the Apostles and with Christ himself.

Venerated as a saint in both East and West, in 1882 St. Cyril was proclaimed a Doctor of the Church by Pope Leo XIII, who at the same time also attributed this title to another important exponent of Greek Patristics, St. Cyril of Jerusalem. Thus are revealed the attention and

[1] Pope Benedict XVI, General Audience, October 3, 2007.

St. Cyril of Alexandria, private collection

love for the Eastern Christian traditions of this pope, who later also chose to proclaim St. John Damascene a Doctor of the Church, thereby showing that both the Eastern and Western traditions express the doctrine of Christ's one Church.

We have almost no information on Cyril's life prior to his election to the important See of Alexandria. He was a nephew of Theophilus, who had governed the Diocese of Alexandria as Bishop since A.D. 385 with a prestigious and iron hand. It is likely that Cyril was born in this Egyptian metropolis between A.D. 370 and 380, was initiated into ecclesiastical life while he was still very young and received a good education, both culturally and theologically.

In 403, he went to Constantinople in the retinue of his powerful uncle. It was here that he took part in the so-called "Synod of the Oak" which deposed the bishop of the city, John (later known as "Chrysostom"), and thereby marked the triumph of the Alexandrian See over its traditional rival, the See of Constantinople, where the emperor resided.

Upon his uncle Theophilus's death, the still young Cyril was elected in 412 as bishop of the influential Church of Alexandria, which he governed energetically for thirty-two years, always seeking to affirm her primacy throughout the East, strong also because of her traditional bonds with Rome.

Two or three years later, in 417 or 418, the Bishop of Alexandria showed himself to be realistic in mending the broken communion with Constantinople, which had lasted by then since 406 as a consequence of Chrysostom's deposition. But the old conflict with the Constantinople See flared up again about ten years later, when in 428 Nestorius, a severe and authoritarian monk trained in Antioch, was elected. The new Bishop of Constantinople, in fact, soon provoked opposition because he preferred to use as Mary's title in his preaching "Mother of

St. Cyril of Alexandria, fresco, Staro Nagoricino (Macedonia)

154

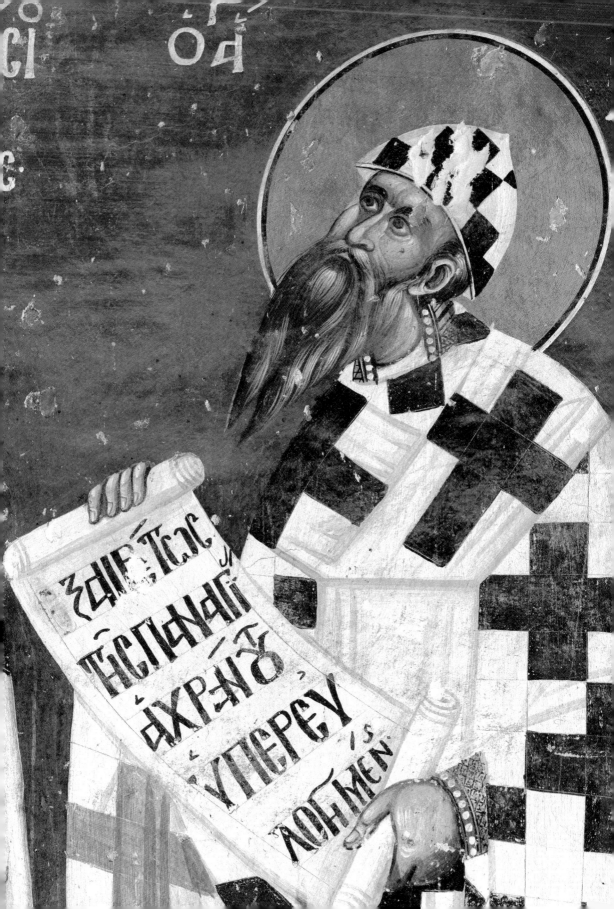

St. Cyril of Beloozero with Scenes from his Life and St. Cyril of Alexandria, Moscow, Tret'jakov Gallery

Christ" (*Christotòkos*) instead of "Mother of God" (*Theotòkos*), already very dear to popular devotion.

One reason for Bishop Nestorius's decision was his adherence to the Antiochean type of Christology, which, to safeguard the importance of Christ's humanity, ended by affirming the division of the Divinity. Hence, the union between God and man in Christ could no longer be true, so naturally it was no longer possible to speak of the "Mother of God."

The reaction of Cyril — at that time the greatest exponent of Alexandrian Christology, who intended on the other hand to stress the unity of Christ's person — was almost immediate, and from 429 he left no stone unturned, even addressing several letters to Nestorius himself. In the second of Cyril's letters to Nestorius (*PG 77*, 44-49), written in February 430, we read a clear affirmation of the duty of pastors to preserve the faith of the People of God. This was his criterion, moreover, still valid today: the faith of the People of God is an expression of tradition, it is a guarantee of sound doctrine.

This is what he wrote to Nestorius: "It is essential to explain the teaching and interpretation of the faith to the people in the most irreproachable way, and to remember that those who cause scandal even to only one of the little ones who believe in Christ will be subjected to an unbearable punishment."

In the same letter to Nestorius — a letter which later, in 451, was to be approved by the Council of Chalcedon, the Fourth Ecumenical Council — Cyril described his Christological faith clearly: "Thus, we affirm that the natures are different that are united in one true unity, but from both has come only one Christ and Son; not because, due to their unity, the difference in their natures has been eliminated, but rather, because divinity and humanity, reunited in an ineffable and indescribable union, have produced for us one Lord and Christ and Son."

And this is important: true humanity and true divinity are really united in only one Person, Our Lord Jesus Christ. Therefore, the Bishop

of Alexandria continued: "We will profess only one Christ and Lord, not in the sense that we worship the man together with the *Logos,* in order not to suggest the idea of separation by saying 'together,' but in the sense that we worship only one and the same, because he is not extraneous to the *Logos,* his body, with which he also sits at his Father's side, not as if 'two sons' are sitting beside him but only one, united with his own flesh."

And soon the Bishop of Alexandria, thanks to shrewd alliances, obtained the repeated condemnation of Nestorius: by the See of Rome, consequently with a series of twelve anathemas which he himself composed, and finally, by the Council held in Ephesus in 431, the Third Ecumenical Council. The assembly which went on with alternating and turbulent events, ended with the first great triumph of devotion to Mary and with the exile of the Bishop of Constantinople, who had been reluctant to recognize the Blessed Virgin's right to the title of "Mother of God" because of an erroneous Christology that brought division to Christ himself.

After thus prevailing against his rival and his doctrine, by 433 Cyril was nevertheless already able to achieve a theological formula of compromise and reconciliation with the Antiocheans. This is also significant: on the one hand is the clarity of the doctrine of faith, but in addition, on the other, the intense search for unity and reconciliation. In the following years he devoted himself in every possible way to defending and explaining his theological stance, until his death on June 27, 444.

Cyril's writings — truly numerous and already widely disseminated in various Latin and Eastern translations in his own lifetime, attested to by their instant success — are of the utmost importance for the history of Christianity. His commentaries on many of the New and Old Testament Books are important, including those on the entire Pentateuch, Isaiah, the Psalms and the Gospels of John and Luke. Also important are his many doctrinal works, in which the defense of the

Trinitarian faith against the Arian and Nestorian theses recurs. The basis of Cyril's teaching is the ecclesiastical tradition and in particular, as I mentioned, the writings of Athanasius, his great predecessor in the See of Alexandria.

Among Cyril's other writings, the books *Against Julian* deserve mention. They were the last great response to the anti-Christian controversies, probably dictated by the Bishop of Alexandria in the last years of his life to respond to the work *Against the Galileans,* composed many years earlier in 363 by the emperor known as the "Apostate" for having abandoned the Christianity in which he was raised.

The Christian faith is first and foremost the encounter with Jesus, "a Person, which gives life a new horizon" (*Deus Caritas Est,* n. 1). St. Cyril of Alexandria was an unflagging, staunch witness of Jesus Christ, the Incarnate Word of God, emphasizing above all his unity, as he repeats in 433 in his first letter (*PG* 77, 228–237) to Bishop Successus: "Only one is the Son, only one the Lord Jesus Christ, both before the Incarnation and after the Incarnation. Indeed, the *Logos* born of God the Father was not one Son and the one born of the Blessed Virgin another; but we believe that the very One who was born before the ages was also born according to the flesh and of a woman."

Over and above its doctrinal meaning, this assertion shows that faith in Jesus the *Logos* born of the Father is firmly rooted in history because, as St. Cyril affirms, this same Jesus came in time with his birth from Mary, the *Theotòkos,* and in accordance with his promise will always be with us. And this is important: God is eternal, he is born of a woman, and he stays with us every day. In this trust we live, in this trust we find the way for our life.

CHAPTER SEVENTEEN

St. Hilary of Poitiers[1]

I would like to talk about a great Father of the Church of the West, St. Hilary of Poitiers, one of the important episcopal figures of the fourth century. In the controversy with the Arians, who considered Jesus the Son of God to be an excellent human creature but only human, Hilary devoted his whole life to defending faith in the divinity of Jesus Christ, Son of God, and God as the Father who generated him from eternity.

We have no reliable information on most of Hilary's life. Ancient sources say that he was born in Poitiers, probably in about the year A.D. 310. From a wealthy family, he received a solid literary education, which is clearly recognizable in his writings. It does not seem that he grew up in a Christian environment. He himself tells us of a quest for the truth which led him little by little to recognize God the Creator and the incarnate God who died to give us eternal life.

Baptized in about 345, he was elected bishop of his native city around 353–354. In the years that followed, Hilary wrote his first work, *Commentary on St. Matthew's Gospel*. It is the oldest extant commentary in Latin on this Gospel. In 356, Hilary took part as a bishop in the Synod of Béziers in the South of France, the "synod of false apostles,"

as he himself called it since the assembly was in the control of philo-Arian Bishops who denied the divinity of Jesus Christ. "These false apostles" asked the Emperor Constantius to have the Bishop of Poitiers sentenced to exile. Thus, in the summer of 356, Hilary was forced to leave Gaul.

Banished to Phrygia in present-day Turkey, Hilary found himself in contact with a religious context totally dominated by Arianism. Here too, his concern as a pastor impelled him to work strenuously to re-establish the unity of the Church on the basis of right faith as formulated by the Council of Nicaea. To this end he began to draft his own best-known and most important dogmatic work: *De Trinitate* (On the Trinity). Hilary explained in it his personal journey toward knowledge of God and took pains to show that not only in the New Testament but also in many Old Testament passages, in which Christ's mystery already appears, Scripture clearly testifies to the divinity of the Son and his equality with the Father.

To the Arians he insisted on the truth of the names of Father and Son, and developed his entire Trinitarian theology based on the formula of baptism given to us by the Lord himself: "In the name of the Father and of the Son and of the Holy Spirit."

The Father and the Son are of the same nature. And although several passages in the New Testament might make one think that the Son was inferior to the Father, Hilary offers precise rules to avoid mislead-ing interpretations: some Scriptural texts speak of Jesus as God, others highlight instead his humanity. Some refer to him in his pre-existence with the Father; others take into consideration his state of emptying of self *(kenosis),* his descent to death; others, finally, contemplate him in the glory of the Resurrection.

In the years of his exile, Hilary also wrote the *Book of Synods* in which, for his brother bishops of Gaul, he reproduced confessions of

Parmigianino, *St. Hilary*, fresco, Parma (Italy), Church of San Giovanni Evangelista

DNI EST TERRE ET PLENITVDO EIVS

MAISTRE ESTIENDE CHLR

faith and commented on them and on other documents of synods which met in the East in about the middle of the fourth century. Ever adamant in opposing the radical Arians, St. Hilary showed a conciliatory spirit to those who agreed to confess that the Son was essentially *similar* to the Father, seeking of course to lead them to the true faith, according to which there is not only a likeness but a true equality of the Father and of the Son in divinity. This too seems to me to be characteristic: the spirit of reconciliation that seeks to understand those who have not yet arrived and helps them with great theological intelligence to reach full faith in the true divinity of the Lord Jesus Christ.

In 360 or 361, Hilary was finally able to return home from exile and immediately resumed pastoral activity in his Church, but the influence of his magisterium extended in fact far beyond its boundaries.

Gentleness and a strong faith. A synod celebrated in Paris in 360 or 361 borrows the language of the Council of Nicaea. Several ancient authors believe that this anti-Arian turning point of the Gaul episcopate was largely due to the fortitude and docility of the Bishop of Poitiers. This was precisely his gift: to combine strength in the faith and docility in interpersonal relations.

In the last years of his life he also composed the *Treatises on the Psalms*, a commentary on fifty-eight Psalms interpreted according to the principle highlighted in the introduction to the work: "There is no doubt that all the things that are said in the Psalms should be understood in accordance with Gospel proclamation, so that, whatever the voice with which the prophetic spirit has spoken, all may be referred nevertheless to the knowledge of the coming of Our Lord Jesus Christ, the Incarnation, Passion and Kingdom, and to the power and glory of our resurrection" (*Instructio Psalmorum*, 5).

He saw in all the Psalms this transparency of the mystery of Christ and of his Body which is the Church. Hilary met St. Martin on various

Jean Foquet, *St. Hilary at the Council*, miniature from *Book of the Hours of Étienne Chevalier*, Chantilly (France), Musée Condée

165

occasions: the future Bishop of Tours founded a monastery right by Poitiers, which still exists today. Hilary died in 367. His liturgical Memorial is celebrated on January 13. In 1851 Blessed Pius IX proclaimed him a Doctor of the universal Church.

To sum up the essentials of his doctrine, I would like to say that Hilary found the starting point for his theological reflection in baptismal faith. In *De Trinitate,* Hilary writes: Jesus "has commanded us to baptize *in the name of the Father and of the Son and of the Holy Spirit* (cf. Mt 28:19), that is, in the confession of the Author, of the Only-Begotten One and of the Gift. The Author of all things is one alone, for *one alone is God the Father, from whom all things proceed.* And *one alone is Our Lord Jesus Christ, through whom all things exist* (cf. 1 Cor 8:6), *and one alone is the Spirit* (cf. Eph 4:4), a gift in all.... In nothing can be found to be lacking so great a fullness, in which the immensity in the Eternal One, the revelation in the Image, joy in the Gift, converge in the Father, in the Son, and in the Holy Spirit" (*De Trinitate* 2, 1).

God the Father, being wholly love, is able to communicate his divinity to his Son in its fullness. I find particularly beautiful the following formula of St. Hilary: "God knows not how to be anything other than love, he knows not how to be anyone other than the Father. Those who love are not envious and the one who is the Father is so in his totality. This name admits no compromise, as if God were father in some aspects and not in others" (*De Trinitate* 9, 61).

For this reason the Son is fully God without any gaps or diminishment. "The One who comes from the perfect is perfect because he has all, he has given all" (*De Trinitate* 2, 8). Humanity finds salvation in Christ alone, Son of God and Son of man. In assuming our human nature, he has united himself with every man, "he has become the flesh of us all" (*Tractatus super Psalmos* 54, 9); "he took on himself the nature of all flesh and through it became true life; he has in himself the root of every vine shoot" (*Tractatus super Psalmos* 51, 16). For this very reason the way to Christ is open to all — because he has drawn

all into his being as a man — even if personal conversion is always required: "Through the relationship with his flesh, access to Christ is open to all, on condition that they divest themselves of their former self (cf. Eph 4:22), nailing it to the Cross (cf. Col 2:14); provided we give up our former way of life and convert in order to be buried with him in his baptism, in view of life (cf. Col 1:12; Rom 6:4)" (*Tractatus super Psalmos* 91, 9).

Fidelity to God is a gift of his grace. Therefore, St. Hilary asks, at the end of his Treatise on the Trinity, to be able to remain ever faithful to the baptismal faith. It is a feature of this book: reflection is transformed into prayer and prayer returns to reflection. The whole book is a dialogue with God.

I would like to end this catechesis with one of these prayers, which thus becomes our prayer: "Obtain, O Lord," St. Hilary recites with inspiration, "that I may keep ever faithful to what I have professed in the symbol of my regeneration, when I was baptized in the Father, in the Son and in the Holy Spirit. That I may worship you, our Father, and with you, your Son; that I may deserve your Holy Spirit, who proceeds from you through your Only Begotten Son... Amen" (*De Trinitate* 12, 57).

de leur pres sieges en la terre de rome. en
lan enfuiuant eufebe euefque de uerfeilles
mouuit. lij. de faint eufebe de uerfeilles et
de fes fais.

t reuit non t baptefine de eufebe pape.
t uraiement le pape eufebe si fu entro
duit de langre auant quil le baptizaft
quel t comment il feroit grant homme
t hoineste. t parquel non il lappelleroit

St. Eusebius of Vercelli[1]

I invite you to reflect on St. Eusebius of Vercelli, the first Bishop of Northern Italy of whom we have reliable information. Born in Sardinia at the beginning of the fourth century, he moved to Rome with his family at a tender age. Later, he was instituted lector: he thus came to belong to the clergy of the city at a time when the Church was seriously troubled by the Arian heresy. The high esteem that developed around Eusebius explains his election in A.D. 345 to the Episcopal See of Vercelli.

The new bishop immediately began an intense process of evangelization in a region that was still largely pagan, especially in rural areas. Inspired by St. Athanasius — who had written the *Life of St. Anthony*, the father of monasticism in the East — he founded a priestly community in Vercelli that resembled a monastic community. This coenobium impressed upon the clergy of Northern Italy a significant hallmark of apostolic holiness and inspired important episcopal figures such as Limenius and Honoratus, successors of Eusebius in Vercelli; Gaudentius

[1] Pope Benedict XVI, General Audience, October 17, 2007.

Baptism of St. Eusebius, miniature from *Historical Mirror*, Paris, National Library of France

in Novara; Exuperantius in Tortona; Eustasius in Aosta; Eulogius in Ivrea; and Maximus in Turin, all venerated by the Church as saints.

With his sound formation in the Nicene faith, Eusebius did his utmost to defend the full divinity of Jesus Christ, defined by the Nicene *Creed* as "of one being with the Father." To this end, he allied himself with the great Fathers of the fourth century — especially St. Athanasius, the standard bearer of Nicene orthodoxy — against the philo-Arian policies of the Emperor. For the Emperor, the simpler Arian faith appeared politically more useful as the ideology of the Empire. For him it was not truth that counted but rather political opportunism: he wanted to exploit religion as the bond of unity for the Empire. But these great Fathers resisted him, defending the truth against political expediency.

Eusebius was consequently condemned to exile, as were so many other bishops of the East and West: such as Athanasius himself, Hilary of Poitiers — of whom we spoke earlier in this book — and Hosius of Cordoba. In Scythopolis, Palestine, to which he was exiled between 355 and 360, Eusebius wrote a marvelous account of his life. Here too, he founded a monastic community with a small group of disciples. It was also from here that he attended to his correspondence with his faithful in Piedmont, as can be seen in the second of the three *Letters* of Eusebius recognized as authentic.

Later, after 360, Eusebius was exiled to Cappadocia and the Thebaid, where he suffered serious physical ill treatment. After his death in 361, Constantius II was succeeded by the Emperor Julian, known as "the Apostate," who was not interested in making Christianity the religion of the empire but merely wished to restore paganism. He rescinded the banishment of these bishops and thereby also enabled Eusebius to be reinstated in his See. In 362 he was invited by Anastasius to take part in the Council of Alexandria, which decided to pardon the Arian

Nicolò Corso, *Sts. Eusebius and Agnes*, Genoa (Italy),
Museo dell'Accademia Ligustica de Belle Arti

bishops as long as they returned to the secular state. Eusebius was able to exercise his episcopal ministry for another ten years, until he died, creating an exemplary relationship with his city which did not fail to inspire the pastoral service of other bishops of Northern Italy, whom we shall reflect upon in other chapters, such as St. Ambrose of Milan and St. Maximus of Turin.

The Bishop of Vercelli's relationship with his city is illustrated in particular by two testimonies in his correspondence. The first is found in the *letter* cited above, which Eusebius wrote from his exile in Scythopolis "to the beloved brothers and priests missed so much, as well as to the holy people with a firm faith of Vercelli, Novara, Ivrea and Tortona" (*Second Letter, CCL* 9, p. 104). These first words, which demonstrate the deep emotion of the good pastor when he thought of his flock, are amply confirmed at the end of the *letter* in his very warm fatherly greetings to each and every one of his children in Vercelli, with expressions overflowing with affection and love.

One should note first of all the explicit relationship that bound the bishop to the *sanctae plebes,* not only of *Vercellae/*Vercelli — the first and subsequently for some years the only diocese in the Piedmont — but also of *Novaria/* Novara, *Eporedia/*Ivrea and *Dertona/* Tortona; that is, of the Christian communities in the same diocese which had become quite numerous and acquired a certain consistency and autonomy. Another interesting element is provided by the farewell with which the *letter* concludes. Eusebius asked his sons and daughters to give his greeting "also to those who are outside the Church, yet deign to nourish feelings of love for us: *etiam hos, qui foris sunt et nos dignantur diligere.*" This is an obvious proof that the bishop's relationship with his city was not limited to the Christian population but also extended to those who — outside the Church — recognized in some way his spiritual authority and loved this exemplary man.

The second testimony of the bishop's special relationship with his city comes from the *letter* St. Ambrose of Milan wrote to the Vercellians

in about 394, more than 20 years after Eusebius's death (*Ep. Extra Col-lecitonem* 14: *Maur.* 63). The Church of Vercelli was going through a difficult period: she was divided and lacked a bishop. Ambrose frankly declared that he hesitated to recognize these Vercellians as descending from "the lineage of the holy fathers who approved of Eusebius as soon as they saw him, without ever having known him previously and even forgetting their own fellow citizens."

In the same *letter,* the Bishop of Milan attested to his esteem for Eusebius in the clearest possible way: "Such a great man," he wrote in peremptory tones, "well deserves to be elected by the whole of the Church." Ambrose's admiration for Eusebius was based above all on the fact that the Bishop of Vercelli governed his diocese with the witness of his life: "With the austerity of fasting he governed his Church."

Indeed, Ambrose was also fascinated, as he himself admits, by the monastic ideal of the contemplation of God which, in the footsteps of the Prophet Elijah, Eusebius had pursued. First of all, Ambrose com-mented, the Bishop of Vercelli gathered his clergy in *vita communis* and educated its members in "the observance of the monastic rule, although they lived in the midst of the city." The bishop and his clergy were to share the problems of their fellow citizens and did so credibly, precisely by cultivating at the same time a different citizenship, that of heaven (cf. Heb 13:14). And thus, they really built true citizenship and true solidarity among all the citizens of Vercelli.

While Eusebius was adopting the cause of the *sancta plebs* of Ver-celli, he lived a monk's life in the heart of the city, opening the city to God. This trait, though, in no way diminished his exemplary pastoral dynamism.

It seems among other things that he set up parishes in Vercelli for an orderly and stable ecclesial service and promoted Marian shrines for the conversion of the pagan populations in the countryside. This "monas-tic feature," however, conferred a special dimension on the bishop's relationship with his hometown. Just like the Apostles, for whom Jesus

173

prayed at his Last Supper, the pastors and faithful of the Church "are in the world" (Jn 17: 11), but not "of the world." Therefore, pastors, Eusebius said, must urge the faithful not to consider the cities of the world as their permanent dwelling places but to seek the future city, the definitive heavenly Jerusalem.

This "eschatological reserve" enables pastors and the faithful to preserve the proper scale of values without ever submitting to the fashions of the moment and the unjust claims of the current political power. The authentic scale of values — Eusebius's whole life seems to say — does not come from emperors of the past or of today but from Jesus Christ, the perfect Man, equal to the Father in divinity, yet a man like us. In referring to this scale of values, Eusebius never tired of "warmly recommending" his faithful "to jealously guard the faith, to preserve harmony, to be assiduous in prayer" *Second Letter, op. cit.*).

Dear friends, I, too, warmly recommend these perennial values to you, using the very words with which the holy Bishop Eusebius concluded his *Second Letter*: "I address you all, my holy brothers and sisters, sons and daughters, faithful of both sexes and of every age group, so that you may... bring our greeting also to those who are outside the Church, yet deign to nourish sentiments of love for us" (*Second Letter, op. cit.*).

Anton Raphael Mengs, *The Glory of St. Eusebius*, fresco, Rome, Church of Sant'Eusebio

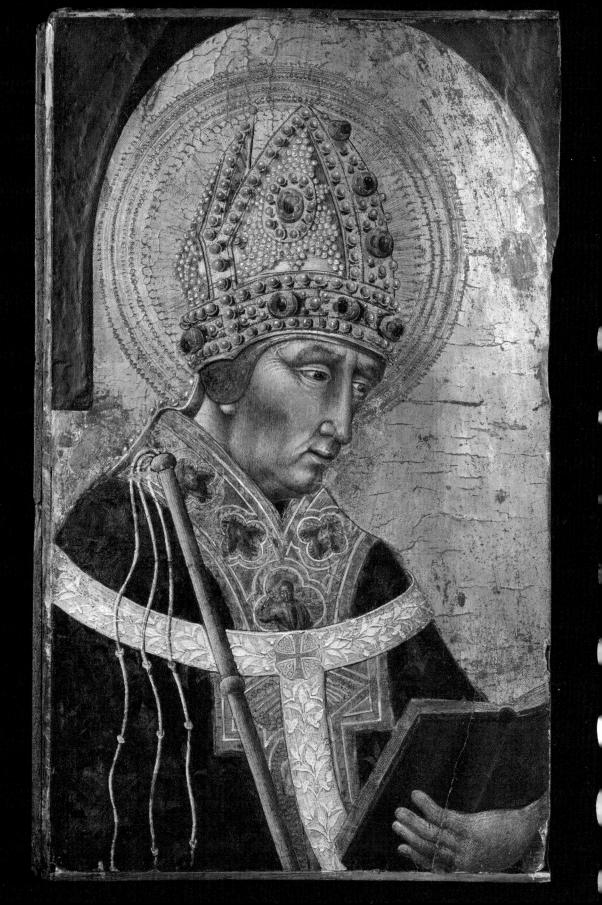

St. Ambrose of Milan[1]

Holy Bishop Ambrose died in Milan in the night between the 3rd and 4th of April 397.

It was dawn on Holy Saturday. The day before, at about five o'clock in the afternoon, he had settled down to pray, lying on his bed with his arms wide open in the form of a cross. Thus, he took part in the solemn Easter Triduum, in the death and Resurrection of the Lord. *"We saw his lips moving,"* said Paulinus, the faithful deacon who wrote his *Life* at St. Augustine's suggestion, "but we could not hear his voice."

The situation suddenly became dramatic. Honoratus, Bishop of Vercelli, who was assisting Ambrose and was sleeping on the upper floor, was awoken by a voice saying again and again, "Get up quickly! Ambrose is dying...." "Honoratus hurried downstairs," Paulinus continues, "and offered the saint the Body of the Lord. As soon as he had received and swallowed it, Ambrose gave up his spirit, taking the good Viaticum with him. His soul, thus refreshed by the virtue of that food, now enjoys the company of Angels" (*Life*, 47). On that Holy Friday 397, the wide-open arms of the dying Ambrose expressed his mystical participation in the death and Resurrection of the Lord. This was his

[1] Pope Benedict XVI, General Audience, October 24, 2007.

Giovanni di Paolo, *St. Ambrose*, New York, Metropolitan Museum of Art

last catechesis: in the silence of the words, he continued to speak with the witness of his life.

Ambrose was not old when he died. He had not even reached the age of sixty, since he was born in about A.D. 340 in Treves, where his father was Prefect of the Gauls. His family was Christian.

Upon his father's death while he was still a boy, his mother took him to Rome and educated him for a civil career, assuring him a sound instruction in rhetoric and jurisprudence. In about 370 he was sent to govern the Provinces of Emilia and Liguria, with headquarters in Milan. It was precisely there that the struggle between orthodox and Arians was raging and became particularly heated after the death of the Arian Bishop Auxentius. Ambrose intervened to pacify the members of the two opposing factions; his authority was such that although he was merely a catechumen, the people acclaimed him Bishop of Milan.

Until that moment, Ambrose had been the most senior magistrate of the Empire in northern Italy. Culturally well-educated but at the same time ignorant of the Scriptures, the new bishop briskly began to study them. From the works of Origen, the indisputable master of the "Alexandrian School," he learned to know and to comment on the Bible. Thus, Ambrose transferred to the Latin environment the meditation on the Scriptures which Origen had begun, introducing in the West the practice of *lectio divina*.

The method of *lectio* served to guide all of Ambrose's preaching and writings, which stemmed precisely from *prayerful listening* to the Word of God. The famous introduction of an Ambrosian catechesis shows clearly how the holy bishop applied the Old Testament to Christian life: "Every day, when we were reading about the lives of the Patriarchs and the maxims of the Proverbs, we addressed morality," the Bishop of Milan said to his catechumens and neophytes, "so that formed and instructed by them you may become accustomed to taking the path

Benozzo Gozzoli, *St. Ambrose Baptizes St. Augustine*, fresco, San Gimignano (Italy), Church of Sant'Agostino

TE DEV̄ LAV DAM̄
TED OMINV CO FIEM̄

ADI PRIMO DAPRILE MILLE CCCC LXIIII

of the Fathers and to following the route of obedience to the divine precepts" (*On the Mysteries* 1, 1).

In other words, the neophytes and catechumens, in accordance with the bishop's decision, after having learned the art of a well-ordered life, could henceforth consider themselves prepared for Christ's great mysteries. Thus, Ambrose's preaching — which constitutes the structural nucleus of his immense literary opus — starts with the reading of the Sacred Books ("the Patriarchs" or the historical Books and "Proverbs," or in other words, the Wisdom Books) in order to live in conformity with divine Revelation.

It is obvious that the preacher's personal testimony and the level of exemplarity of the Christian community condition the effectiveness of the preaching. In this perspective, a passage from St. Augustine's *Confessions* is relevant. He had come to Milan as a teacher of rhetoric; he was a sceptic and not Christian. He was seeking the Christian truth but was not capable of truly finding it.

What moved the heart of the young African rhetorician, sceptic and downhearted, and what impelled him to definitive conversion was not above all Ambrose's splendid homilies (although he deeply appreciated them). It was rather the testimony of the bishop and his Milanese Church that prayed and sang as one intact body. It was a Church that could resist the tyrannical ploys of the emperor and his mother, who in early 386 again demanded a church building for the Arians' celebrations. In the building that was to be requisitioned, Augustine relates, "the devout people watched, ready to die with their bishop." This testimony of the *Confessions* is precious because it points out that something was moving in Augustine, who continues: "We too, although spiritually tepid, shared in the excitement of the whole people" (*Confessions* 9, 7).

Augustine learned from the life and example of Bishop Ambrose to believe and to preach. We can refer to a famous sermon of the African, which centuries later merited citation in the conciliar Constitution on Divine Revelation, *Dei Verbum:* "Therefore, all clerics, particularly

priests of Christ and others who, as deacons or catechists, are officially engaged in the ministry of the Word," *Dei Verbum* recommends, "should immerse themselves in the Scriptures by constant sacred reading and diligent study. For it must not happen that anyone becomes" — and this is Augustine's citation — "'an empty preacher of the Word of God to others, not being a hearer of the Word in his own heart'" (n. 25). Augustine had learned precisely from Ambrose how to "hear in his own heart" this perseverance in reading Sacred Scripture with a prayerful approach, so as truly to absorb and assimilate the Word of God in one's heart.

Dear brothers and sisters, I would like further to propose to you a sort of "patristic icon," which, interpreted in the light of what we have said, effectively represents "the heart" of Ambrosian doctrine. In the sixth book of the *Confessions,* Augustine tells of his meeting with Ambrose, an encounter that was indisputably of great importance in the history of the Church.

He writes in his text that whenever he went to see the Bishop of Milan, he would regularly find him taken up with *catervae* of people full of problems for whose needs he did his utmost. There was always a long queue waiting to talk to Ambrose, seeking in him consolation and hope. When Ambrose was not with them, with the people (and this happened for the space of the briefest of moments), he was either restoring his body with the necessary food or nourishing his spirit with reading.

Here Augustine marvels because Ambrose read the Scriptures with his mouth shut, only with his eyes (cf. *Confessions*, 6, 3). Indeed, in the early Christian centuries reading was conceived of strictly for proclamation, and reading aloud also facilitated the reader's understanding. That Ambrose could scan the pages with his eyes alone suggested to

On pages 182–183: *St. Ambrose Celebrates Mass for the Death of St. Martin,* mosaic, Milan (Italy), Church of Sant'Ambrogio

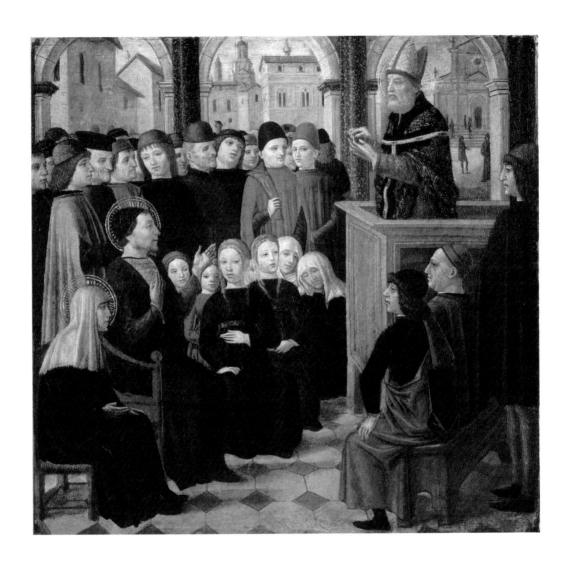

Bergognone, *Preaching of St. Ambrose*, Turin (Italy), Galleria Sabauda

the admiring Augustine a rare ability for reading and familiarity with the Scriptures.

Well, in that "reading under one's breath," where the heart is committed to achieving knowledge of the Word of God — this is the "icon" to which we are referring — one can glimpse the method of Ambrosian catechesis; it is Scripture itself, intimately assimilated, which suggests the content to proclaim that will lead to the conversion of hearts.

Thus, with regard to the magisterium of Ambrose and of Augustine, catechesis is inseparable from witness of life. What I wrote on the theologian in the *Introduction to Christianity* might also be useful to the catechist. An educator in the faith cannot risk appearing like a sort of clown who recites a part "by profession." Rather — to use an image dear to Origen, a writer who was particularly appreciated by Ambrose — he must be like the beloved disciple who rested his head against his Master's heart and there learned the way to think, speak, and act. The true disciple is ultimately the one whose proclamation of the Gospel is the most credible and effective.

Like the Apostle John, Bishop Ambrose — who never tired of saying: "*Omnia Christus est nobis!* To us Christ is all!" — continues to be a genuine witness of the Lord. Like this, let us conclude our catechesis with his same words, full of love for Jesus: "*Omnia Christus est nobis!* If you have a wound to heal, he is the doctor; if you are parched by fever, he is the spring; if you are oppressed by injustice, he is justice; if you are in need of help, he is strength; if you fear death, he is life; if you desire heaven, he is the way; if you are in the darkness, he is light.... Taste and see how good is the Lord: blessed is the man who hopes in him!" (*De Virginitate,* 16, 99). Let us also hope in Christ. We shall thus be blessed and shall live in peace.

OTTAVIANO · S̄ MAXIMO · A AVENMOR

St. Maximus of Turin[1]

Between the end of the fourth century and the beginning of the fifth, another Father of the Church after St. Ambrose made a great contribution to the spread and consolidation of Christianity in Northern Italy: St. Maximus, whom we come across in 398 as Bishop of Turin, a year after St. Ambrose's death. Very little is known about him; in compensation, we have inherited a collection of about ninety of his *Sermons*. It is possible to perceive in them the bishop's profound and vital bond with his city, which attests to an evident point of contact between the episcopal ministry of Ambrose and that of Maximus.

At that time serious tensions were disturbing orderly civil coexistence. In this context, as pastor and teacher, Maximus succeeded in obtaining the Christian people's support. The city was threatened by various groups of barbarians. They entered by the Eastern passes, which went as far as the Western Alps. Turin was therefore permanently garrisoned by troops and at critical moments became a refuge for the populations fleeing from the countryside and urban centers where there was no protection. Maximus's interventions in the face of this situa-

[1] Pope Benedict XVI, General Audience, October 31, 2007.

St. Maximus, Bishop, with Sts. Octavius and Adventor, miniature from the *Book of Statutes*, Turin (Italy), Historical Archive of the City of Turin, Loose Papers, No. 390

tion testify to his commitment to respond to the civil degradation and disintegration.

Although it is still difficult to determine the social composition of those for whom the *Sermons* were intended, it would seem that Maximus's preaching — to avoid the risk of vagueness — was specifically addressed to a chosen nucleus of the Christian community of Turin, consisting of rich landowners who had property in the Turinese countryside and a house in the city. This was a clear-sighted pastoral decision by the bishop, who saw this type of preaching as the most effective way to preserve and strengthen his own ties with the people.

To illustrate this view of Maximus's ministry in his city, I would like to point out for example *Sermons* 17 and 18, dedicated to an ever timely topic: wealth and poverty in Christian communities. In this context too, the city was fraught with serious tensions. Riches were accumulated and hidden. "No one thinks about the needs of others," the bishop remarked bitterly in his seventeenth *Sermon*. "In fact, not only do many Christians not share their own possessions but they also rob others of theirs. Not only, I say, do they not bring the money they collect to the feet of the apostles, but in addition, they drag from priests' feet their own brethren who are seeking help." And he concluded: "In our cities there are many guests or pilgrims. Do what you have promised," adhering to faith, "so that what was said to Ananias will not be said to you as well: 'You have not lied to men, but to God'" (*Sermon* 17, 2–3).

In the next *Sermon*, the eighteenth, Maximus condemns the recurring forms of exploitation of others' misfortunes. "Tell me, Christian," the bishop reprimands his faithful, "tell me why you snatched the booty abandoned by the plunderers? Why did you take home 'ill-gotten gains' as you yourself think, torn apart and contaminated? But perhaps," he continues, "you say you have purchased them, and thereby believe you are avoiding the accusation of avarice. However, this is not the way to equate purchasing with selling. It is a good thing to make purchases, but that means what is sold freely in times of peace, not goods looted

during the sack of a city. . . . So act as a Christian and a citizen who purchases in order to repay" (*Sermon* 18:3).

Without being too obvious, Maximus thus managed to preach a profound relationship between a Christian's and a citizen's duties. In his eyes, living a Christian life also meant assuming civil commitments. Vice-versa, every Christian who, "despite being able to live by his own work, seizes the booty of others with the ferocity of wild beasts"; who "tricks his neighbor, who tries every day to nibble away at the boundaries of others, to gain possession of their produce," does not compare to a fox biting off the heads of chickens but rather to a wolf savaging pigs (*Sermon* 41, 4).

In comparison with the cautious, defensive attitude that Ambrose adopted to justify his famous project of redeeming prisoners of war, the historical changes that occurred in the relationship between the bishop and the municipal institutions are clearly evident. By now sustained through legislation that invited Christians to redeem prisoners, Maximus, with the collapse of the civil authority of the Roman Empire, felt fully authorized in this regard to exercise true control over the city.

This control was to become increasingly extensive and effective until it replaced the irresponsible evasion of the magistrates and civil institutions. In this context, Maximus not only strove to rekindle in the faithful the traditional love for their *hometown*, but he also proclaimed the precise duty to pay taxes, however burdensome and unpleasant that might appear (cf. *Sermon* 26, 2).

In short, the tone and substance of the *Sermons* imply an increased awareness of the bishop's political responsibility in the specific historical circumstances. He was "the lookout tower" posted in the city. Whoever could these watchmen be, Maximus wonders in *Sermon* 92, "other than the most blessed bishops set on a lofty rock of wisdom, so to speak, to defend the peoples and to warn them about the evils approaching in the distance?"

And in *Sermon* 89 the Bishop of Turin describes his task to his faithful, making a unique comparison between the bishop's function and

the function of bees: "Like the bee," he said, bishops "observe bodily chastity, they offer the food of heavenly life using the sting of the law. They are pure in sanctifying, gentle in restoring and severe in punishing." With these words, St. Maximus described the task of the bishop in his time.

In short, historical and literary analysis show an increasing awareness of the political responsibility of the ecclesiastical authority in a context in which it continued de facto to replace the civil authority.

Indeed, the ministry of the Bishop of Northwest Italy, starting with Eusebius, who dwelled in his Vercelli "like a monk," to Maximus of Turin, positioned "like a sentinel" on the highest rock in the city, developed along these lines. It is obvious that the contemporary historical, cultural, and social context is profoundly different.

Today's context is rather the context outlined by my venerable predecessor, Pope John Paul II, in the Post-Synodal Apostolic Exhortation *Ecclesia in Europa*, in which he offers an articulate analysis of the challenges and signs of hope for the Church in Europe today (nn. 6–22). In any case, on the basis of the changed conditions, the believer's duties to his city and his homeland still remain effective. The combination of the commitments of the "honest citizen" with those of the "good Christian" has not in fact disappeared.

In conclusion, to highlight one of the most important aspects of the unity of Christian life, I would like to recall the words of the Pastoral Constitution *Gaudium et Spes*: consistency between faith and conduct, between Gospel and culture. The Council exhorts the faithful "to perform their duties faithfully in the spirit of the Gospel. It is a mistake to think that, because we have here no lasting city, but seek the city which is to come, we are entitled to shirk our earthly responsibilities; this is to forget that by our faith we are bound all the more to fulfill these responsibilities according to the vocation of each one" (n. 43).

In following the Magisterium of St. Maximus and of many other Fathers, let us make our own the Council's desire that the faithful may

be increasingly anxious to "carry out their earthly activity in such a way as to integrate human, domestic, professional, scientific, and technical enterprises with religious values, under whose supreme direction all things are ordered to the glory of God" (Constitution *Gaudium et Spes*) and thus for humanity's good.

St. Jerome

Life and Writings[1]

We now turn our attention to St. Jerome, a Church Father who centered his life on the Bible: he translated it into Latin, commented on it in his works, and above all, strove to live it in practice throughout his long earthly life, despite the well-known difficult, hot-tempered character with which nature had endowed him.

Jerome was born into a Christian family in about A.D. 347 in Stridon. He was given a good education and was even sent to Rome to fine-tune his studies. As a young man he was attracted by the worldly life (cf. *Ep* 22, 7), but his desire for and interest in the Christian religion prevailed.

He received baptism in about 366 and opted for the ascetic life. He went to Aquileia and joined a group of fervent Christians that had formed around Bishop Valerian and which he described as almost "a choir of blessed" (*Chron. ad ann.* 374). He then left for the East and lived as a hermit in the Desert of Chalcis, south of Aleppo (*Ep* 14, 10), devoting himself assiduously to study. He perfected his knowledge of

[1] Pope Benedict XVI, General Audience, November 7, 2007.

Domenico Ghirlandaio, *St. Jerome*, fresco, Florence (Italy), Church of All Saints

Greek, began learning Hebrew (cf. *Ep* 125, 12), and transcribed codices and Patristic writings (cf. *Ep* 5, 2).

Meditation, solitude and contact with the Word of God helped his Christian sensibility to mature. He bitterly regretted the indiscretions of his youth (cf. *Ep.* 22, 7) and was keenly aware of the contrast between the pagan mentality and the Christian life: a contrast made famous by the dramatic and lively "vision" — of which he has left us an account — in which it seemed to him that he was being scourged before God because he was "Ciceronian rather than Christian" (cf. *Ep.* 22, 30).

In 382 he moved to Rome: here, acquainted with his fame as an ascetic and his ability as a scholar, Pope Damasus engaged him as secretary and counselor; the Pope encouraged him, for pastoral and cultural reasons, to embark on a new Latin translation of the Biblical texts. Several members of the Roman aristocracy, especially noblewomen such as Paula, Marcella, Asella, Lea, and others, desirous of committing themselves to the way of Christian perfection and of deepening their knowledge of the Word of God, chose him as their spiritual guide and teacher in the methodical approach to the sacred texts. These noblewomen also learned Greek and Hebrew.

After the death of Pope Damasus, Jerome left Rome in 385 and went on pilgrimage, first to the Holy Land, a silent witness of Christ's earthly life, and then to Egypt, the favorite country of numerous monks (cf. *Contra Rufinum,* 3, 22; *Ep.* 108, 6–14). In 386 he stopped in Bethlehem, where male and female monasteries were built through the generosity of the noblewoman, Paula, as well as a hospice for pilgrims bound for the Holy Land, "remembering Mary and Joseph who had found no room there" (*Ep.* 108, 14).

He stayed in Bethlehem until he died, continuing to do a prodigious amount of work: he commented on the Word of God; he defended the faith, vigorously opposing various heresies; he urged the monks on to perfection; he taught classical and Christian culture to young students; he welcomed with a pastor's heart pilgrims who were visiting the Holy

Land. He died in his cell close to the Grotto of the Nativity on September 30, 419/20.

Jerome's literary studies and vast erudition enabled him to revise and translate many biblical texts: an invaluable undertaking for the Latin Church and for Western culture.

On the basis of the original Greek and Hebrew texts, and thanks to the comparison with previous versions, he revised the four Gospels in Latin, then the Psalter and a large part of the Old Testament. Taking into account the original Hebrew and Greek texts of the Septuagint, the classical Greek version of the Old Testament that dates back to pre-Christian times, as well as the earlier Latin versions, Jerome was able, with the assistance later of other collaborators, to produce a better translation: this constitutes the so-called *"Vulgate,"* the "official" text of the Latin Church which was recognized as such by the Council of Trent and which, after the recent revision, continues to be the "official" Latin text of the Church.

It is interesting to point out the criteria which the great biblicist abided by in his work as a translator. He himself reveals them when he says that he respects even the order of the words of the Sacred Scriptures, for in them, he says, "the order of the words is also a mystery" (*Ep.* 57, 5). that is, a revelation. Furthermore, he reaffirms the need to refer to the original texts: "Should an argument on the New Testament arise between Latins because of interpretations of the manuscripts that fail to agree, let us turn to the original; that is, to the Greek text in which the New Testament was written.

"Likewise, with regard to the Old Testament, if there are divergences between the Greek and Latin texts we should have recourse to the original Hebrew text; thus, we shall be able to find in the streams all that flows from the source" (*Ep.* 106, 2).

Pages 196–197: Colantonio, *St. Jerome Removing a Thorn from a Lion's Paw*, Naples (Italy), Museo Nazionale di Capodimonte

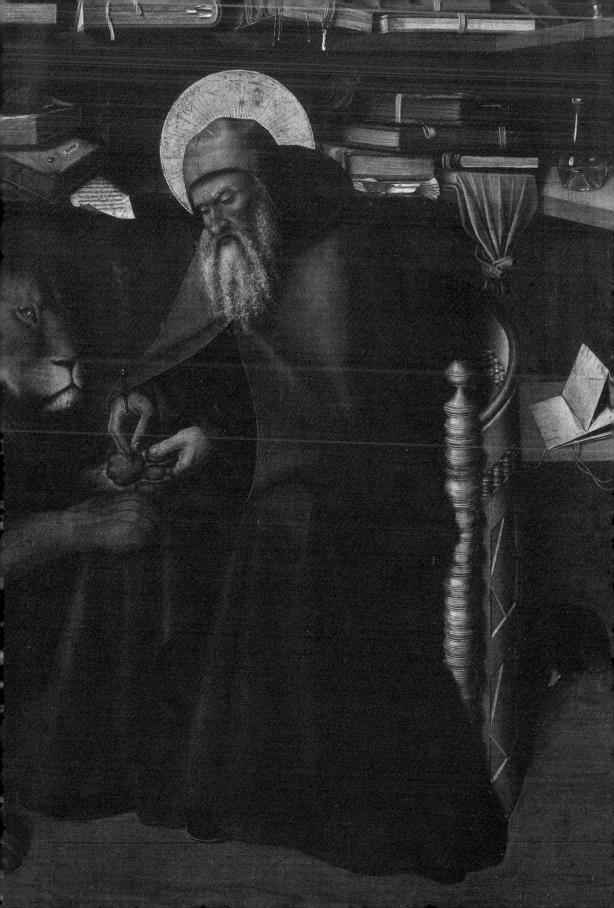

Jerome also commented on many biblical texts. For him the commentaries had to offer multiple opinions "so that the shrewd reader, after reading the different explanations and hearing many opinions — to be accepted or rejected — may judge which is the most reliable, and, like an expert moneychanger, may reject the false coin" (*Contra Rufinum* 1, 16).

Jerome refuted with energy and liveliness the heretics who contested the tradition and faith of the Church. He also demonstrated the importance and validity of Christian literature, which had by then become a real culture that deserved to be compared with classical literature: he did so by composing his *De Viris Illustribus,* a work in which Jerome presents the biographies of more than a hundred Christian authors.

Further, he wrote biographies of monks, comparing among other things their spiritual itineraries as well as monastic ideals. In addition, he translated various works by Greek authors. Lastly, in the important *Epistulae,* a masterpiece of Latin literature, Jerome emerges with the profile of a man of culture, an ascetic and a guide of souls.

What can we learn from St. Jerome? It seems to me, this above all: to love the Word of God in Sacred Scripture. St. Jerome said: "Ignorance of the Scriptures is ignorance of Christ." It is therefore important that every Christian live in contact and in personal dialogue with the Word of God given to us in Sacred Scripture.

This dialogue with Scripture must always have two dimensions: on the one hand, it must be a truly personal dialogue because God speaks with each one of us through Sacred Scripture and it has a message for each one. We must not read Sacred Scripture as a word of the past but as the Word of God that is also addressed to us, and we must try to understand what it is that the Lord wants to tell us.

However, to avoid falling into individualism, we must bear in mind that the Word of God has been given to us precisely in order to build communion and to join forces in the truth on our journey toward God.

Thus, although it is always a personal Word, it is also a Word that builds community, that builds the Church. We must therefore read it in communion with the living Church.

The privileged place for reading and listening to the Word of God is the liturgy, in which, celebrating the Word and making Christ's Body present in the Sacrament, we actualize the Word in our lives and make it present among us. We must never forget that the Word of God transcends time. Human opinions come and go. What is very modern today will be very antiquated tomorrow. On the other hand, the Word of God is the Word of eternal life, it bears within it eternity and is valid forever. By carrying the Word of God within us, we therefore carry within us eternity, eternal life.

I thus conclude with a word St. Jerome once addressed to St. Paulinus of Nola. In it the great exegete expressed this very reality; that is, in the Word of God we receive eternity, eternal life. St. Jerome said: "Seek to learn on earth those truths which will remain ever valid in Heaven" (*Ep.* 53, 10).

Teachings[2]

As already mentioned, St. Jerome dedicated his life to studying the Bible, so much so that he was recognized by my predecessor, Pope Benedict XV, as *"an outstanding doctor in the interpretation of Sacred Scripture."* Jerome emphasized the joy and importance of being familiar with biblical texts: *"Does one not seem to dwell, already here on earth, in the Kingdom of Heaven when one lives with these texts, when one meditates on them, when one does not know or seek anything else?"* (*Ep.* 53, 10).

In reality, to dialogue with God, with his Word, is in a certain sense a presence of heaven, a presence of God. To draw near to the biblical texts, above all the New Testament, is essential for the believer, because "ignorance of the Scriptures is ignorance of Christ." This is his famous

[2] Pope Benedict XVI, General Audience, November 14, 2007.

S·IERONIMVS·
DOCTOR·

phrase, cited also by the Second Vatican Council in the Constitution *Dei Verbum* (n. 25).

Truly "in love" with the Word of God, he asked himself: "How could one live without the knowledge of Scripture, through which one learns to know Christ himself, who is the life of believers?" (*Ep.* 30, 7). The Bible, an instrument "by which God speaks every day to the faithful" (*Ep.* 133, 13), thus becomes a stimulus and source of Christian life for all situations and for each person.

To read Scripture is to converse with God: "If you pray," he writes to a young Roman noblewoman, "you speak with the Spouse; if you read, it is he who speaks to you" (*Ep.* 22, 25). The study of and meditation on Scripture renders man wise and serene (cf. *In Eph.*, Prol.). Certainly, to penetrate the Word of God ever more profoundly, a constant and progressive application is needed. Hence, Jerome recommends to the priest Nepotian: "Read the divine Scriptures frequently; rather, may your hands never set the Holy Book down. Learn here what you must teach" (*Ep.* 52, 7).

To the Roman matron Leta he gave this counsel for the Christian education of her daughter: "Ensure that each day she studies some Scripture passage.... After prayer, reading should follow, and after reading, prayer.... Instead of jewels and silk clothing, may she love the divine Books" (*Ep.* 107, 9, 12). Through meditation on and knowledge of the Scriptures, one "maintains the equilibrium of the soul" (*Ad Eph.*, Prol.). Only a profound spirit of prayer and the Holy Spirit's help can introduce us to understanding the Bible: "In the interpretation of Sacred Scripture we always need the help of the Holy Spirit" (*In Mich.* 1, 1, 10, 15).

A passionate love for Scripture therefore pervaded Jerome's whole life, a love that he always sought to deepen in the faithful, too. He recommends to one of his spiritual daughters: "Love Sacred Scripture, and wisdom will love you; love it tenderly, and it will protect you; honor it,

School of Giotto, *St. Jerome*, fresco, Assisi (Italy), Upper Basilica of St. Francis, vault of the Doctors of the Church

and you will receive its caresses. May it be for you as your necklaces and your earrings" (*Ep.* 130, 20). And again: "Love the science of Scripture, and you will not love the vices of the flesh" (*Ep.* 125, 11).

For Jerome, a fundamental criterion of the method for interpreting the Scriptures was harmony with the Church's Magisterium. We should never read Scripture alone because we meet too many closed doors and could easily slip into error. The Bible has been written by the People of God and for the People of God under the inspiration of the Holy Spirit. Only in this communion with the People of God do we truly enter into the "we," into the nucleus of the truth that God himself wants to tell us. For him, an authentic interpretation of the Bible must always be in harmonious accord with the faith of the Catholic Church. It does not treat of an exegesis imposed on this Book from without; the Book is really the voice of the pilgrim People of God and only in the faith of this People are we "correctly attuned" to understand Sacred Scripture.

Therefore, Jerome admonishes: "Remain firmly attached to the traditional doctrine that you have been taught, so that you can preach according to right doctrine and refute those who contradict it" (*Ep.* 52, 7). In particular, given that Jesus Christ founded his Church on Peter, every Christian, he concludes, must be in communion "with St. Peter's See. I know that on this rock the Church is built" (*Ep.* 15, 2). Consequently, without approximations, he declared: "I am with whoever is united to the teaching of St. Peter" (*Ep.* 16).

Obviously, Jerome does not neglect the ethical aspect. Indeed, he often recalls the duty to harmonize one's life with the divine Word, and only by living it does one also find the capacity to understand it. This consistency is indispensable for every Christian, and particularly for the preacher, so that his actions may never contradict his discourses nor be an embarrassment to him.

Thus, he exhorts the priest Nepotian: "May your actions never be unworthy of your words, may it not happen that, when you preach in church, someone might say to himself: 'Why does he therefore not act

like this?' How could a teacher, on a full stomach, discuss fasting; even a thief can blame avarice; but in the priest of Christ the mind and words must harmonize" (*Ep.* 52, 7). In another epistle Jerome repeats: "Even if we possess a splendid doctrine, the person who feels condemned by his own conscience remains disgraced" (*Ep.* 127, 4).

Also on the theme of consistency he observes: the Gospel must translate into truly charitable behavior, because in each human being the Person of Christ himself is present. For example, addressing the presbyter Paulinus (who then became Bishop of Nola and a saint), Jerome counsels: "The true temple of Christ is the soul of the faithful: adorn it and beautify this shrine, place your offerings in it and receive Christ. What is the use of decorating the walls with precious stones if Christ dies of hunger in the person of the poor?" (*Ep.* 58, 7). Jerome concretizes the need "to clothe Christ in the poor, to visit him in the suffering, to nourish him in the hungry, to house him in the homeless" (*Ep.* 130, 14).

The love of Christ, nourished with study and meditation, makes us rise above every difficulty: "Let us also love Jesus Christ, always seeking union with him: then even what is difficult will seem easy to us" (*Ep.* 22, 40).

Prosper of Aquitaine, who defined Jerome as a "model of conduct and teacher of the human race" (*Carmen de ingratis,* 57), also left us a rich and varied teaching on Christian asceticism. He reminds us that a courageous commitment toward perfection requires constant vigilance, frequent mortifications, even if with moderation and prudence, and assiduous intellectual and manual labor to avoid idleness (cf. *Ep.* 125, 11; 130, 15), and above all obedience to God: "Nothing... pleases God as much as obedience..., which is the most excellent and sole virtue" (*Hom. de Oboedientia: CCL* 78, 552).

The practice of pilgrimage can also be part of the ascetical journey. In particular, Jerome gave an impulse to it in the Holy Land, where pilgrims were welcomed and housed in the lodgings that were built next

to the monastery of Bethlehem, thanks to the generosity of the noble-woman Paula, a spiritual daughter of Jerome (cf. *Ep.* 108, 14).

Lastly, one cannot remain silent about the importance that Jerome gave to the matter of Christian pedagogy (cf. *Ep.* 107; 128). He proposed to form "one soul that must become the temple of the Lord (*Ep.* 107, 4)," a "very precious gem" in the eyes of God (cf. *Ep.* 107, 4, 8–9; also *Ep.* 128, 3–4). With profound intuition he advises to preserve oneself from evil and from the occasions of sin, and to exclude equivocal or dissipating friendships (cf. *Ep.* 107, 4, 8–9; also *Ep.* 128, 3–4).

Above all, he exhorts parents to create a serene and joyful environment around their children, to stimulate them to study and work also through praise and emulation (cf. *Ep.* 107, 4; 128, 1), encouraging them to overcome difficulties, foster good habits, and avoid picking up bad habits, because, and here he cites a phrase of Publius Siro which he heard at school: "it will be difficult for you to correct those things to which you are quietly habituating yourself" (*Ep.* 107, 8).

Parents are the principal educators of their children, the first teachers of life. With great clarity Jerome, addressing a young girl's mother and then mentioning her father, admonishes, almost expressing a fundamental duty of every human creature who comes into existence: "May she find in you her teacher, and may she look to you with the inexperienced wonder of childhood. Neither in you, nor in her father should she ever see behavior that could lead to sin, as it could be copied. Remember that… you can educate her more by example than with words" (*Ep.* 107, 9).

Among Jerome's principal intuitions as a pedagogue, one must emphasize the importance he attributed to a healthy and integral education beginning from early childhood, with the particular responsibility belonging to parents, the urgency for a serious moral and religious formation and the duty to study for a complete human formation. More-

Antonello da Messina, *St. Jerome in His Study*, London, National Gallery

204

RATE[R]

ambrosius tua m[ihi] mu[nuscula]
p[er]ferens detulit & suau[issimas]
litteras. que a p[ri]ncipio a[micicie]
fidem p[ro]bate iam fide[i] [et]
amicicie p[re]ferebant. vera enim illa necessi[tudo]
[est] & xp̄i glutino copulata. quam no[n] utilitas rei fam[iliaris]
n[on] presentia tantum corpum. n[on] subdola [et] palp[an]s
[adula]tio. s[ed] dei timor [et] diuinar[um] scripturar[um] studia con[ciliant].
Legimus in ue[ter]ib[us] hystoriis quosdam lustras[se]
[prouinci]as. nouos adisse p[o]p[u]los. maria t[ra]nsisse. ut eos
[quos] ex libris nouerant. coram q[uoque] uiderint. Sic pitagoras
[memphi]ticos uates. sic plato egyptum [et] archita[m] tare[n]
[tinum] eande[m]q[ue] ora[m] ytalie que q[u]ondam magna grecia d[icebatur]
laboriosissime p[er]agrauit. ut qui athenis magist[er]
[erat et] potens. cuiusq[ue] doctrinas achademie gimnasia p[er]sonabant
fieret p[ere]g[ri]nus atq[ue] discipulus[.] malens aliena u[erecunde]
discere. quam sua inpudent[er] ingerere. Deniq[ue] [cum] lit
teras quasi toto fugientes orbe p[er]sequit[ur]. cap[tus]
[a] p[ir]atis [et] uenundat[us]. etiam tyranno crudelissimo pa[ruit]

over, an aspect rather disregarded in ancient times but held vital by our author is the promotion of the woman, to whom he attributes the right to a complete formation: human, scholastic, religious, professional.

We see precisely today how the education of the personality in its totality, the education to responsibility before God and man, is the true condition of all progress, all peace, all reconciliation, and the exclusion of violence. Education before God and man: it is Sacred Scripture that offers us the guide for education and thus of true humanism.

We cannot conclude these quick notes on the great Father of the Church without mentioning his effective contribution to safeguarding the positive and valid elements of the ancient Hebrew, Greek, and Roman cultures for nascent Christian civilization. Jerome recognized and assimilated the artistic values of the richness of the sentiments and the harmony of the images present in the classics, which educate the heart and fantasy to noble sentiments. Above all, he put at the center of his life and activity the Word of God, which indicates the path of life to man and reveals the secrets of holiness to him. We cannot fail to be deeply grateful for all of this, even in our day.

St. Jerome and St. Paulinus, drop capital from a Bible, Paris,
National Library of France
On pages 208–209: Caravaggio, *St. Jerome,* Rome, Galleria Borghese

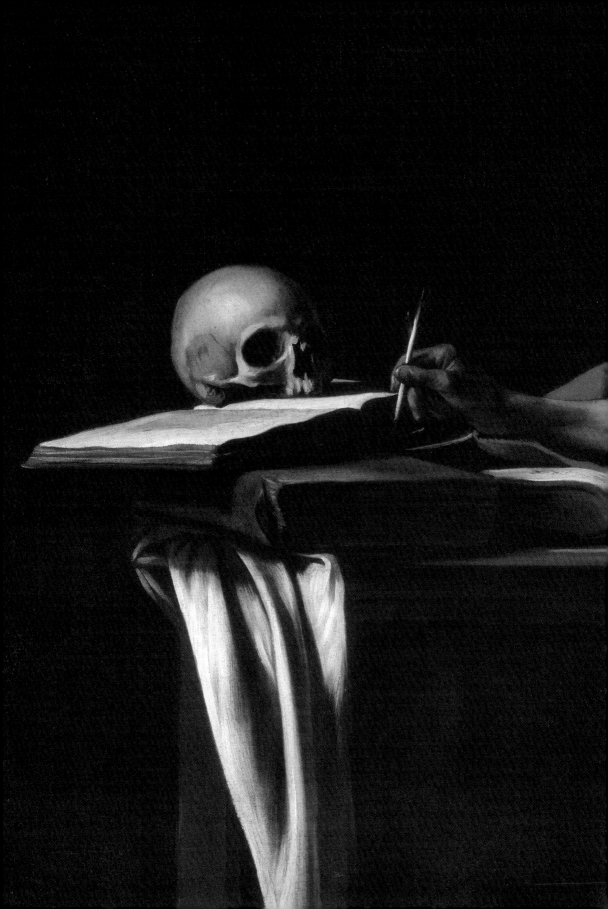

Aphraates, "the Sage"[1]

In our excursion into the world of the Fathers of the Church, I would like to guide you to a little-known part of this universe of faith, in the territories where the Semitic-language Churches flourished, still uninfluenced by Greek thought. These Churches developed throughout the fourth century in the Near East, from the Holy Land to Lebanon and to Mesopotamia. In that century, which was a period of formation on the ecclesial and literary level, these communities contributed to the ascetic-monastic phenomenon with autochthonous characteristics that did not come under Egyptian monastic influence.

The Syriac communities of the fourth century, therefore, represent the Semitic world from which the Bible itself has come, and they are an expression of a Christianity whose theological formulation had not yet entered into contact with different cultural currents, but lived in their own way of thinking. They are Churches in which asceticism in its various hermitic forms (hermits in the desert, caverns, recluses, stylites) and monasticism in forms of community life, exert a role of vital importance in the development of theological and spiritual thought.

[1] Pope Benedict XVI, General Audience, November 21, 2007.

Rabula Gospels, Syriac manuscript from Mesopotamia, Florence (Italy), Biblioteca Medicea Laurenziana

I would like to introduce this world through the great figure of Aphraates, known also by the sobriquet "the Sage." He was one of the most important and at the same time most enigmatic personages of fourth century Syriac Christianity. A native of the Ninive-Mossul region, today in Iraq, he lived during the first half of the fourth century. We have little information about his life; he maintained, however, close ties with the ascetic-monastic environment of the Syriac-speaking Church, of which he has given us some information in his work and to which he dedicates part of his reflection.

Indeed, according to some sources he was the head of a monastery and later consecrated a bishop. He wrote twenty-three homilies, known as *Expositions* or *Demonstrations,* on various aspects of Christian life, such as faith, love, fasting, humility, prayer, the ascetic life, and also the relationship between Judaism and Christianity, between the Old and New Testaments. He wrote in a simple style with short sentences and sometimes with contrasting parallelisms; nevertheless, he was able to weave consistent discourses with a well-articulated development of the various arguments he treated.

Aphraates was from an Ecclesial Community situated on the frontier between Judaism and Christianity. It was a community strongly linked to the Mother Church of Jerusalem, and its Bishops were traditionally chosen from among the so-called "family" of James, the "brother of the Lord" (cf. Mk 6:3). They were people linked by blood and by faith to the Church of Jerusalem. Aphraates' language was Syriac, therefore a Semitic language like the Hebrew of the Old Testament and like the Aramaic spoken by Jesus himself.

Aphraates' Ecclesial Community was a community that sought to remain faithful to the Judeo-Christian tradition, of which it felt it was a daughter. It therefore maintained a close relationship with the Jewish world and its Sacred Books. Significantly, Aphraates defines himself as a "disciple of the Sacred Scripture" of the Old and New Testaments

(*Expositions* 22, 26), which he considers as his only source of inspiration, having recourse to it in such abundance as to make it the center of his reflection.

Aphraates develops various arguments in his *Expositions*. Faithful to Syriac tradition, he often presents the salvation wrought by Christ as a healing, and thus Christ himself as the physician.

Sin, on the other hand, is seen as a wound that only penance can heal: "A man who has been wounded in battle," Aphraates said, "is not ashamed to place himself in the hands of a wise doctor...; in the same way, the one who has been wounded by Satan must not be ashamed to recognize his fault and distance himself from it, asking for the medicine of penance" (*Expositions* 7, 3).

Another important aspect in Aphraates' work is his teaching on prayer, and in a special way on Christ as the teacher of prayer. The Christian prays following Jesus' teaching and example of oration: "Our Savior taught people to pray like this, saying: 'Pray in secret to the One who is hidden, but who sees all'; and again: 'Go into your room and shut the door and pray to your Father who is in secret; and your Father who sees in secret will reward you' (Mt 6:6).... Our Savior wants to show that God knows the desires and thoughts of the heart" (*Expositions* 4, 10).

For Aphraates, the Christian life is centered on the imitation of Christ, in taking up his yoke and following him on the way of the Gospel. One of the most useful virtues for Christ's disciple is humility. It is not a secondary aspect in the Christian's spiritual life: man's nature is humble and it is God who exalts it to his own glory. Aphraates observed that humility is not a negative value: "If man's roots are planted in the earth, his fruits ascend before the Lord of majesty" (*Expositions* 9, 14). By remaining humble, including in the earthly reality in which one lives, the Christian can enter into relationship with the Lord: "The humble man is humble, but his heart rises to lofty heights. The eyes of

his face observe the earth and the eyes of his mind the lofty heights" (*Expositions* 9, 2).

Aphraates' vision of man and his physical reality is very positive: the human body, in the example of the humble Christ, is called to beauty, joy, and light: "God draws near to the man who loves, and it is right to love humility and to remain in a humble state. The humble are simple, patient, loving, integral, upright, good, prudent, calm, wise, quiet, peaceful, merciful, ready to convert, benevolent, profound, thoughtful, beautiful, and attractive" (*Expositions* 9, 14).

Aphraates often presented the Christian life in a clear ascetic and spiritual dimension: faith is the base, the foundation; it makes of man a temple where Christ himself dwells. Faith, therefore, makes sincere charity possible, which expresses itself in love for God and neighbor. Another important aspect in Aphraates' thought is fasting, which he understood in a broad sense. He spoke of fasting from food as a necessary practice to be charitable and pure, of fasting understood as continence with a view to holiness, of fasting from vain or detestable words, of fasting from anger, of fasting from the possession of goods with a view to ministry, of fasting from sleep to be watchful in prayer.

Dear brothers and sisters, to conclude, we return again to Aphraates' teaching on prayer. According to this ancient "Sage," prayer is achieved when Christ dwells in the Christian's heart, and invites him to a coherent commitment to charity toward one's neighbor. In fact, he wrote:

> Give relief to those in distress, visit the ailing,
> help the poor: this is prayer.
> Prayer is good, and its works are beautiful.
> Prayer is accepted when it gives relief to one's neighbor.
> Prayer is heard when it includes forgiveness of affronts.
> Prayer is strong
> when it is full of God's strength. (*Expositions* 4, 14–16.)

With these words Aphraates invites us to a prayer that becomes Christian life, a fulfilled life, a life penetrated by faith, by openness to God and therefore to love of neighbor.

St. Ephrem, the Syrian[1]

Common opinion today supposes Christianity to be a European religion which subsequently exported the culture of this continent to other countries. But the reality is far more complex since the roots of the Christian religion are found in the Old Testament; hence, in Jerusalem and the Semitic world. Christianity is still nourished by these Old Testament roots. Furthermore, its expansion in the first centuries was both toward the West — toward the Greco-Latin world, where it later inspired European culture — and in the direction of the East, as far as Persia and India. It thus contributed to creating a specific culture in Semitic languages with an identity of its own.

To demonstrate this cultural pluralism of the one Christian faith in its origins, I spoke in a previous chapter of a representative of this other Christianity who is almost unknown to us: Aphraates, the Persian sage. Along the same lines, I would like to talk about St. Ephrem, the Syrian, who was born into a Christian family in Nisibis in about A.D. 306. He was Christianity's most important Syriac-speaking representative and uniquely succeeded in reconciling the vocations of theologian and poet.

[1] Pope Benedict XVI, General Audience, November 28, 2007.

St. Ephrem, fresco, Leptokaria (Greece), Kanalou Monastery, Chapel of Agios Dimìtrios

He was educated and grew up beside James, Bishop of Nisibis (303–338), and with him founded the theological school in his city. He was ordained a deacon and was intensely active in local Christian community life until 363, the year when Nisibis fell into Persian hands. Ephrem then emigrated to Edessa, where he continued his activity as a preacher. He died in this city in 373, a victim of the disease he contracted while caring for those infected with the plague.

It is not known for certain whether he was a monk, but we can be sure in any case that he remained a deacon throughout his life and embraced virginity and poverty. Thus, the common and fundamental Christian identity appears in the specificity of his own cultural expression: faith, hope — the hope which makes it possible to live poor and chaste in this world, placing every expectation in the Lord — and lastly, charity, to the point of giving his life through nursing those sick with the plague.

St. Ephrem has left us an important theological inheritance. His substantial opus can be divided into four categories: works written in ordinary prose (his polemic works or biblical commentaries); works written in poetic prose; homilies in verse; and lastly, hymns, undoubtedly Ephrem's most abundant production. He is a rich and interesting author in many ways, but especially from the theological point of view. It is the fact that theology and poetry converge in his work which makes it so special.

If we desire to approach his doctrine, we must insist on this from the outset: namely, on the fact that he produces theology in poetical form. Poetry enabled him to deepen his theological reflection through paradoxes and images. At the same time, his theology became liturgy, became music; indeed, he was a great composer, a musician. Theology, reflection on the faith, poetry, song, and praise of God go together; and it is precisely in this liturgical character that the divine truth emerges clearly in Ephrem's theology.

In his search for God, in his theological activity, he employed the way of paradoxes and symbols. He made ample use of contrasting images because they served to emphasize the mystery of God.

I cannot present much of his writing here, partly because his poetry is difficult to translate, but to give at least some idea of his poetical theology I would like to cite parts of two hymns. First of all, I shall propose to you several splendid images taken from his hymns *On the Nativity of Christ*. Ephrem expressed his wonder before the Virgin in inspired tones:

"The Lord entered her and became a servant; the Word entered her, and became silent within her; thunder entered her and his voice was still; the Shepherd of all entered her; he became a Lamb in her, and came forth bleating.

"The belly of your Mother changed the order of things, O you who order all! Rich he went in, he came out poor: the High One went into her [Mary], he came out lowly. Brightness went into her and clothed himself, and came forth a despised form. . . .

"He that gives food to all went in, and knew hunger. He who gives drink to all went in, and knew thirst. Naked and bare came forth from her the Clother of all things [in beauty]" (Hymn *De Nativitate* 11:6–8).

To express the mystery of Christ, Ephrem uses a broad range of topics, expressions, and images. In one of his hymns he effectively links Adam (in Paradise) to Christ (in the Eucharist):

"It was by closing with the sword of the cherub that the path to the tree of life was closed. But for the peoples, the Lord of this tree gave himself as food in his (Eucharistic) oblation.

"The trees of the Garden of Eden were given as food to the first Adam. For us, the gardener of the Garden in person made himself food for our souls. Indeed, we had all left Paradise together with Adam, who left it behind him.

Dormition of St. Ephrem the Syrian, Athens, Byzantine Museum

221

"Now that the sword has been removed here below (on the Cross), replaced by the spear, we can return to it" (*Hymn* 49: 9–11).

To speak of the Eucharist, Ephrem used two images, embers or burning coal and the pearl. The burning coal theme was taken from the Prophet Isaiah (cf. Is 6:6). It is the image of one of the seraphim who picks up a burning coal with tongs and simply touches the lips of the Prophet with it in order to purify them; the Christian, on the other hand, touches and consumes the Burning Coal which is Christ himself:

"In your bread hides the Spirit who cannot be consumed; in your wine is the fire that cannot be swallowed. The Spirit in your bread, fire in your wine: behold a wonder heard from our lips.

"The seraph could not bring himself to touch the glowing coal with his fingers, it was Isaiah's mouth alone that it touched; neither did the fingers grasp it nor the mouth swallow it; but the Lord has granted us to do both these things.

"The fire came down with anger to destroy sinners, but the fire of grace descends on the bread and settles in it. Instead of the fire that destroyed man, we have consumed the fire in the bread and have been invigorated" (Hymn *De Fide* 10: 8–10).

Here again is a final example of St. Ephrem's hymns, where he speaks of the pearl as a symbol of the riches and beauty of faith:

"I placed (the pearl), my brothers, on the palm of my hand, to be able to examine it. I began to look at it from one side and from the other: it looked the same from all sides. (Thus) is the search for the Son inscrutable, because it is all light. In its clarity I saw the Clear One who does not grow opaque; and in his purity, the great symbol of the Body of Our Lord, which is pure. In his indivisibility I saw the truth which is indivisible" (Hymn *On the Pearl* 1: 2–3).

The figure of Ephrem is still absolutely timely for the life of the various Christian Churches. We discover him in the first place as a theologian who reflects poetically, on the basis of Holy Scripture, on

the mystery of man's redemption brought about by Christ, the Word of God incarnate. His is a theological reflection expressed in images and symbols taken from nature, daily life and the Bible.

Ephrem gives his poetry and liturgical hymns a didactic and catechetical genre: they are theological hymns yet at the same time suitable for recitation or liturgical song. On the occasion of liturgical feasts, Ephrem made use of these hymns to spread Church doctrine. Time has proven them to be an extremely effective catechetical instrument for the Christian community.

Ephrem's reflection on the theme of God the Creator is important: nothing in creation is isolated and the world, next to Sacred Scripture, is a Bible of God. By using his freedom wrongly, man upsets the cosmic order.

The role of women was important to Ephrem. The way he spoke of them was always inspired with sensitivity and respect: the dwelling place of Jesus in Mary's womb greatly increased women's dignity. Ephrem held that just as there is no Redemption without Jesus, there is no Incarnation without Mary.

The divine and human dimensions of the mystery of our redemption can already be found in Ephrem's texts; poetically and with fundamentally scriptural images, he anticipated the theological background and in some way the very language of the great Christological definitions of the fifth-century Councils.

Ephrem, honored by Christian tradition with the title "Harp of the Holy Spirit," remained a deacon of the Church throughout his life. It was a crucial and emblematic decision: he was a deacon, a servant, in his liturgical ministry, and more radically, in his love for Christ, whose praises he sang in an unparalleled way, and also in his love for his brethren, whom he introduced with rare skill to the knowledge of divine Revelation.

gati sint uniuersi in ihrlm. celebrare le
ticiam socdin testamentum dni dei irsrahel.

Romatio. et heliodoro epis. et ihe
rontinus psbiter in dno salutem.
Illrari non desmo: exactionis uestre in
stantiam. Exigitis enim ut librum chaldeo

St. Chromatius of Aquileia[1]

In the last two chapters we made an excursion through the Eastern Churches of Semitic tongue, meditating on Aphraates the Persian and Ephrem the Syrian. Now, we return to the Latin world, to the North of the Roman Empire with St. Chromatius of Aquileia. This bishop exercised his ministry in the ancient Church of Aquileia, a fervent center of Christian life located in the Roman Empire's *Decima regione*, the *Venetia et Histria*.

In A.D. 388, when Chromatius assumed the episcopal throne of the city, the local Christian communities had already developed a glorious history of Gospel fidelity. Between the middle of the third century and the early years of the fourth, the persecution of Decius, Valerian, and Diocletian had taken a heavy toll of martyrs. Furthermore, the Church of Aquileia, like so many other Churches of that time, had had to contend with the threat of the Arian heresy.

Athanasius himself — a standard-bearer of Nicene orthodoxy whom the Arians had banished to exile — had for some time been in Aquileia, where he had taken refuge. Under the guidance of its Bishops, the

[1] Pope Benedict XVI, General Audience, December 5, 2007.

St. Chromatius of Aquileia, miniature from the *Bible of Hiesterback*, Berlin, Staatsbibliothek, Ms. Theol. Lat. 379, fol. 205r

Christian community withstood the snares of the heresy and reinforced their own attachment to the Catholic faith.

In September 381, Aquileia was the seat of a synod that gathered about thirty-five bishops from the coasts of Africa, the Rhone Valley and the entire *Decima regione*. The synod intended to eliminate the last remnants of Arianism in the West. Chromatius, a priest, also took part in the Council as *peritus* for Bishop Valerian of Aquileia (370/1–387/8). The years around the Synod of 381 were the "Golden Age" of the inhabitants of Aquileia. St. Jerome, a native of Dalmatia, and Rufinus of Concordia, spoke nostalgically of their sojourn in Aquileia (370–373), in that sort of theological cenacle which Jerome did not hesitate to define *"tamquam chorus beatorum,"* "like a choir of blessed" (*Cronaca: PL* XXVII, 697–698). It was in this Upper Room — some aspects of which are reminiscent of the community experiences directed by Eusebius of Vercelli and by Augustine — that the most outstanding figures of the Church of the Upper Adriatic were formed.

Chromatius, however, had already learned at home to know and love Christ. Jerome himself spoke of this in terms full of admiration and compared Chromatius's mother to the Prophetess Anna, his two sisters to the Wise Virgins of the Gospel Parable, and Chromatius himself and his brother Eusebius to the young Samuel (cf. *Ep.* VII: *PL* XXII, 341). Jerome wrote further of Chromatius and Eusebius: "Blessed Chromatius and St. Eusebius were brothers by blood, no less than by the identity of their ideals" (*Ep.* VIII: *PL* XXII, 342).

Chromatius was born in Aquileia in about A.D. 345. He was ordained a deacon, then a priest; finally, he was appointed Bishop of that Church (388). After receiving episcopal ordination from Bishop Ambrose he dedicated himself courageously and energetically to an immense task because of the vast territory entrusted to his pastoral care: the ecclesiastical jurisdiction of Aquileia, in fact, stretched from the present-day territories of Switzerland, Bavaria, Austria and Slovenia, as far as Hungary.

How well known and highly esteemed Chromatius was in the Church of his time we can deduce from an episode in the life of St. John Chrysostom. When the Bishop of Constantinople was exiled from his See, he wrote three letters to those he considered the most important bishops of the West seeking to obtain their support with the emperors: he wrote one letter to the Bishop of Rome, the second to the Bishop of Milan and the third to the Bishop of Aquileia, precisely, Chromatius (*Ep.* CLV: *PG* LII, 702). Those were difficult times also for Chromatius because of the precarious political situation. In all likelihood Chromatius died in exile, in Grado, while he was attempting to escape the incursions of the Barbarians in 407, the same year when Chrysostom also died.

With regard to prestige and importance, Aquileia was the fourth city of the Italian peninsula and the ninth of the Roman Empire. This is another reason that explains why it was a target that attracted both Goths and Huns. In addition to causing serious bereavements and destruction, the invasions of these peoples gravely jeopardized the transmission of the works of the Fathers preserved in the episcopal library, rich in codices.

St. Chromatius's writings were also dispersed, ending up here and there, and were often attributed to other authors: to John Chrysostom (partly because of the similar beginning of their two names, *Chr*omatius and *Chr*ysostom); or to Ambrose or Augustine; or even to Jerome, to whom Chromatius had given considerable help in the revision of the text and in the Latin translation of the Bible. The rediscovery of a large part of the work of Chromatius is due to fortunate events, which has made it possible only in recent years to piece together a fairly consistent *corpus* of his writings: more than forty homilies, ten of which are fragments, and more than sixty treatises of commentary on Matthew's Gospel.

Chromatius was a wise *teacher* and a zealous *pastor.* His first and main commitment was to listen to the Word, to be able to subsequently

proclaim it: he always bases his teaching on the Word of God and constantly returns to it. Certain subjects are particularly dear to him: first of all, the *Trinitarian mystery,* which he contemplated in its revelation throughout the history of salvation.

Then, the theme of the *Holy Spirit:* Chromatius constantly reminds the faithful of the presence and action in the life of the Church of the Third Person of the Most Holy Trinity. But the holy bishop returns with special insistence to the *mystery of Christ.* The Incarnate Word is true God and true man: he took on humanity in its totality to endow it with his own divinity. These truths, which he also reaffirmed explicitly in order to counter Arianism, were to end up about fifty years later in the definition of the Council of Chalcedon.

The heavy emphasis on Christ's human nature led Chromatius to speak of the *Virgin Mary.* His Mariological doctrine is clear and precise. To him we owe evocative descriptions of the Virgin Most Holy: Mary is the "evangelical Virgin capable of accepting God"; she is the "immaculate and inviolate ewe lamb" who conceived the "Lamb clad in purple" (cf. *Sermo* XXIII, 3: *Scrittori dell'Area Santambrosiana* 3/1, p. 134). The Bishop of Aquileia often compares the Virgin with the Church: both, in fact, are "virgins" and "mothers."

Chromatius developed his *ecclesiology* above all in his commentary on Matthew. These are some of the recurring concepts: the Church is one, she is born from the Blood of Christ; she is a precious garment woven by the Holy Spirit; the Church is where the fact that Christ was born of a Virgin is proclaimed, where brotherhood and harmony flourish.

One image of which Chromatius is especially fond is that of the ship in a storm — and his were stormy times, as we have heard: "There is no doubt," the Holy Bishop says, "that this ship represents the Church" (cf. *Tractatus* XVI, 3: *Scrittori dell'Area Santambrosiana* 3/2, p. 106).

As the zealous pastor that he was, Chromatius was able to speak to his people with a fresh, colorful, and incisive language. Although

he was not ignorant of the perfect Latin *cursus,* he preferred to use the vernacular, rich in images easy to understand. Thus, for example, drawing inspiration from the sea, he compared on the one hand the natural catching of fish which, caught and landed, die; and on the other, Gospel preaching, thanks to which men and women are saved from the murky waters of death and ushered into true life (cf. *Tractatus* XVI, 3: *Scrittori dell'Area Santambrosiana* 3/2, p. 106). Again, in the perspective of a good pastor, during a turbulent period such as his, ravaged by the incursions of Barbarians, he was able to set himself beside the faithful to comfort them and open their minds to trust in God, who never abandons his children.

Lastly, as a conclusion to these reflections, let us include an exhortation of Chromatius which is still perfectly applicable today: "Let us pray to the Lord with all our heart and with all our faith," the Bishop of Aquileia recommends in one of his *Sermons.* "Let us pray to him to deliver us from all enemy incursions, from all fear of adversaries. Do not look at our merits but at his mercy, at him who also in the past deigned to set the Children of Israel free, not for their own merits but through his mercy.

"May he protect us with his customary merciful love and bring about for us what holy Moses said to the Children of Israel: *The Lord will fight to defend you, and you will be silent.* It is he who fights, it is he who wins the victory.... And so that he may condescend to do so, we must pray as much as possible. He himself said, in fact, through the mouth of the prophet: *Call on me on the day of tribulation; I will set you free and you will give me glory"* (*Sermo* XVI, 4: *Scrittori dell'Area Santambrosiana* 3/2, pp. 100–102).

St. Chromatius reminds us of prayer in which it is essential to enter into contact with God. God knows us, he knows me, he knows each one of us, he loves me, he will not abandon me. Let us go forward with this trust.

CHAPTER TWENTY-FIVE

St. Paulinus of Nola[1]

The Father of the Church to whom we now turn our attention is St. Paulinus of Nola. Paulinus, a contemporary of St. Augustine to whom he was bound by a firm friendship, exercised his ministry at Nola in Campania, where he was a monk and later a priest and a bishop. However, he was originally from Aquitaine in the South of France, to be precise, Bordeaux, where he was born into a high-ranking family. It was here, with the poet Ausonius as his teacher, that he received a fine literary education.

He left his native region for the first time to follow his precocious political career, which was to see him rise while still young to the position of Governor of Campania. In this public office he attracted admiration for his gifts of wisdom and gentleness. It was during this period that grace caused the seed of conversion to grow in his heart. The incentive came from the simple and intense faith with which the people honored the tomb of a saint, Felix the Martyr, at the shrine of present-day Cimitile. As the head of public government, Paulinus took

[1] Pope Benedict XVI, General Audience, December 12, 2007.

St. Paulinus of Nola and St. Felix, Bishop, fresco, Pernosano (Italy), Church of Santa Maria Assunta

an interest in this shrine and had a hospice for the poor built and a road to facilitate access to it for the many pilgrims.

While he was doing his best to build the city on earth, he continued discovering the way to the city in heaven. The encounter with Christ was the destination of a laborious journey, strewn with ordeals. Difficult circumstances which resulted from his loss of favor with the political authorities made the transience of things tangible to him.

Once he had arrived at faith, he was to write: "*The man without Christ is dust and shadow*" (*Carm.* X, 289). Anxious to shed light on the meaning of life, he went to Milan to attend the school of Ambrose. He then completed his Christian formation in his native land, where he was baptized by Bishop Delphinus of Bordeaux. Marriage was also a landmark on his journey of faith. Indeed, he married Therasia, a devout noblewoman from Barcelona, with whom he had a son. He would have continued to live as a good lay Christian had not the infant's death after only a few days intervened to rouse him, showing him that God had other plans for his life. Indeed, he felt called to consecrate himself to Christ in a rigorous ascetic life.

In full agreement with his wife Therasia, he sold his possessions for the benefit of the poor and, with her, left Aquitaine for Nola. Here, the husband and wife settled beside the Basilica of the Patron Saint, Felix, living henceforth in chaste brotherhood according to a form of life which also attracted others. The community's routine was typically monastic, but Paulinus, who had been ordained a priest in Barcelona, took it upon himself despite his priestly status to care for pilgrims. This won him the liking and trust of the Christian community, which chose Paulinus, upon the death of the bishop in about 409, as his successor in the See of Nola.

Paulinus intensified his pastoral activity, distinguished by special attention to the poor. He has bequeathed to us the image of an authentic pastor of charity, as St. Gregory the Great described him in chapter III of his *Dialogues*, in which he depicts Paulinus in the heroic gesture

Andrea Sabatini, *St. Paulinus*, Nola (Italy), diocesan museum

of offering himself as a prisoner in the place of a widow's son. The historical truth of this episode is disputed, but the figure of a bishop with a great heart who knew how to make himself close to his people in the sorrowful trials of the barbarian invasions lives on.

Paulinus's conversion impressed his contemporaries. His teacher Ausonius, a pagan poet, felt "betrayed" and addressed bitter words to him, reproaching him on the one hand for his "contempt," considered insane, of material goods, and on the other, for abandoning his literary vocation. Paulinus replied that giving to the poor did not mean contempt for earthly possessions but rather an appreciation of them for the loftiest aim of charity.

As for literary commitments, what Paulinus had taken leave of was not his poetic talent — which he was to continue to cultivate — but poetic forms inspired by mythology and pagan ideals. A new aesthetic now governed his sensibility: the beauty of God incarnate, crucified and risen, whose praises he now sang. Actually, he had not abandoned poetry but was henceforth to find his inspiration in the Gospel, as he says in this verse: "To my mind the only art is the faith, and Christ is my poetry" ("*At nobis ars una fides, et musica Christus*": *Carm.*, XX, 32).

Paulinus's poems are songs of faith and love in which the daily history of small and great events is seen as a history of salvation, a history of God with us. Many of these compositions, the so-called *Carmina natalicia*, are linked to the annual feast of Felix the Martyr, whom he had chosen as his heavenly patron. Remembering St. Felix, Paulinus desired to glorify Christ himself, convinced as he was that the saint's intercession had obtained the grace of conversion for him: "In your light, joyful, I loved Christ" (*Carm.* XXI, 373).

He desired to express this very concept by enlarging the shrine with a new basilica, which he had decorated in such a way that the paintings, described by suitable captions, would constitute a visual catechesis for pilgrims. Thus, he explained his project in a poem dedicated to another great catechist, St. Nicetas of Remesiana, as he accompanied him on a

visit to his basilicas: "I now want you to contemplate the paintings that unfold in a long series on the walls of the painted porticos. . . . It seemed to us useful to portray sacred themes in painting throughout the house of Felix, in the hope that when the peasants see the painted figure, these images will awaken interest in their astonished minds" (*Carm.* XXVII, vv. 511, 580–583). Today, it is still possible to admire the remains of these works which rightly place the Saint of Nola among the figures with a Christian archaeological reference.

Life in accordance with the ascetic discipline of Cimitile was spent in poverty and prayer and was wholly immersed in *lectio divina*. Scripture, read, meditated upon and assimilated, was the light in whose brightness the Saint of Nola examined his soul as he strove for perfection. He told those who were struck by his decision to give up material goods that this act was very far from representing total conversion. "The relinquishment or sale of temporal goods possessed in this world is not the completion but only the beginning of the race in the stadium; it is not, so to speak, the goal, but only the starting point. In fact, the athlete does not win because he strips himself, for he undresses precisely in order to begin the contest, whereas he only deserves to be crowned as victorious when he has fought properly" (cf. *Ep.* XXIV, 7 to Sulpicius Severus).

After the ascetic life and the Word of God came charity; the poor were at home in the monastic community. Paulinus did not limit himself to distributing alms to them: he welcomed them as though they were Christ himself. He reserved a part of the monastery for them and by so doing, it seemed to him that he was not so much giving as receiving, in the exchange of gifts between the hospitality offered and the prayerful gratitude of those assisted. He called the poor his "masters" (cf. *Ep.* XIII, 11 to Pammachius) and, remarking that they were housed on the lower floor, liked to say that their prayers constituted the foundation of his house (cf. *Carm.* XXI, 393–394).

St. Paulinus did not write theological treatises, but his poems and ample correspondence are rich in a lived theology, woven from God's

235

Word, constantly examined as a light for life. The sense of the Church as a mystery of unity emerges in particular from them.

Paulinus lived communion above all through a pronounced practice of spiritual friendship. He was truly a master in this, making his life a crossroads of elect spirits: from Martin of Tours to Jerome, from Ambrose to Augustine, from Delphinus of Bordeaux to Nicetas of Remesiana, from Victricius of Rouen to Rufinus of Aquileia, from Pammachius to Sulpicius Severus and many others, more or less well known.

It was in this atmosphere that the intense pages written to Augustine came into being. Over and above the content of the individual letters, one is impressed by the warmth with which the Saint of Nola sings of friendship itself as a manifestation of the one Body of Christ, enlivened by the Holy Spirit. Here is an important passage that comes at the beginning of the correspondence between the two friends: "It is not surprising if, despite being far apart, we are present to each other and, without being acquainted, know each other, because we are members of one body, we have one head, we are steeped in one grace, we live on one loaf, we walk on one road and we dwell in the same house" (*Ep.* VI, 2). As can be seen, this is a very beautiful description of what it means to be Christian, to be the Body of Christ, to live within the Church's communion.

The theology of our time has found the key to approaching the mystery of the Church precisely in the concept of communion. The witness of St. Paulinus of Nola helps us to perceive the Church, as she is presented to us by the Second Vatican Council, as a sacrament of intimate union with God; hence, of unity among all of us and, lastly, among the whole human race (cf. *Lumen Gentium*, n. 1).

Limbourg Brothers, *St. Ambrose Baptizes St. Augustine*, miniature from *The Very Rich Hours of the Duke of Berry*, Chantilly (France), Musée Condée, Ms. 65, fol. 37v

Te deum lau
damus te
dominum confitemur.
Te eternum pa
trem omnis
terra venera
tur.

Tibi om
nes angeli
tibi celi et u
niuerse pote
states.

Tibi cheru
bin et serap
him: incessa
bili uoce pro
clamant.

Sanctus
Sanctus. sanctus
dominus deus sabaoth
Pleni sunt celi et ter
ra maiestatis glie tue.

Te gloriosus apo
stolorum chorus.

Te prophetaru
laudabilis numer?

Te mar
tirum can
didatus lau
dat exercitus.

Te per or
bem terraru
sancta confi
tetur ecclia.

Patrem
inmense ma
iestatis.

Veneran
dum tuum
uerum et u
nicum filium.

Sanctum quoq; pa
raclitum spiritum.

Tu rex glorie xpe.

Urn of St. Paulinus, Sanctuary of St. Paulinus, Sutera (Italy)

239

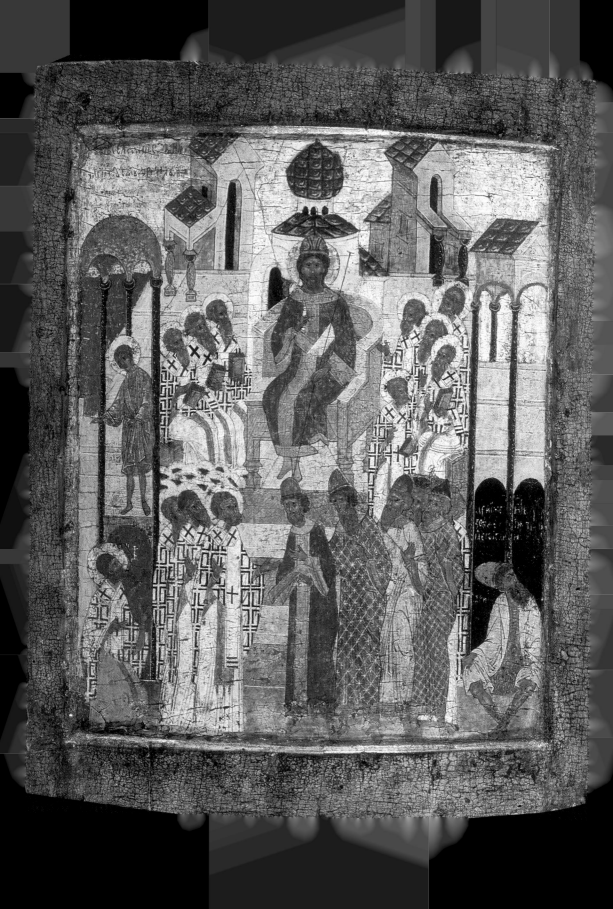

Index of General Audiences

First Ecumenical Council of Nicaea, School of Novgorod, Intesa Sanpaolo Collection, Vincenza (Italy), Palazzo Leoni Montanari Gallery

Index of Illustrations

246

Art Credits

Alinari Archive, Florence (Italy) — granted by the Ministry of Cultural Goods and Activities: 68, 196–197, 208–209

Andrea Jemolo Archive, Rome (Italy): 134, 155

The Bridgeman Art Library/Alinari Archive, Florence (Italy): 31, 72, 121, 136, 146–147, 152, 205

Contrasto/Lessing: 37, 146–147, 6

Foto Scala, Florence (Italy): 8–9, 13, 18, 84, 160, 163, 171, 182–183

Foto Scala, Florence (Italy) — granted by the Ministry of Cultural Goods and Activities: 20, 22–23, 26, 179, 184

Foto Scala, Florence (Italy)/BPK, Bildagentur für Kunst, Kultur und Geschichte, Berlin: 145, 224

Foto Scala, Florence (Italy)/HIP: 14

Franco Cosimo Panini Editore by license of Fratelli Alinari: 200

Historical Archive of the City of Turin (Italy): 186

Intesa Sanpaolo Collection: 237

The Metropolitan Museum of Art/Art Resource/Scala, Florence (Italy): 176

National Library of France: 54, 124, 130, 168, 206

Office of Sacred Art and Cultural Goods of the Church, Diocese of Nola (Italy): 233, 230

Photoservice Electa: 76, 104, 210

Photoservice Electa/AKG Images: cover, 50, 62, 71, 90–91, 109, 112, 149, 156, 164, 216, 237

Photoservice Electa/Leemage: 92, 210

RMN/© Gérard Blot: 34

Pope Benedict XVI
books available from
Our Sunday Visitor

The Apostles
The Apostles, Illustrated Edition
Study Guide to The Apostles

The Fathers
The Fathers, Illustrated Edition — Volumes I and II
Companion Guide to Pope Benedict's The Fathers

Saint Paul the Apostle

Questions and Answers

Breakfast with Benedict: Daily Readings

www.osv.com or 1-800-348-2440